ABSOLUTELY
Appleby

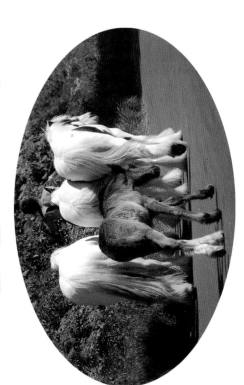

Heidi M Sands

Old Pond
PUBLISHING LTD

Symbolic painting of animals is all important to the travelling community and while the exterior is much admired the interior can be even more surprising with cut glass mirrors and ruby glass panels.

First published 2013

Copyright © Heidi M Sands, 2013

Heidi M Sands has asserted her right under the
Copyright, Designs and Patents Act, 1988, to be
identified as Author of this Work

ISBN 978-1-908397-59-1

Old Pond Publishing Ltd
Dencora Business Centre
36 White House Road
Ipswich IP1 5LT
United Kingdom

www.oldpond.com

All photographs and text
are by Heidi M Sands
Book design by Liz Whatling
Printed and bound in China

Introduction

In May 2011 my first book for Old Pond, *The Horses of Appleby Fair*, was published. It featured, as the title suggests, horses taking part in the age-old ritual of Appleby Horse Fair with pictures of them swimming in the river, trotting on the flashing lane – more usually known as the Long Marton road – lazing in the sun on Fair Hill or drawing bow top caravans, vardos or wagons into Appleby. The pictures were vivid and flamboyant and provided a unique glimpse into a way of life seldom seen by those outside the gypsy and traveller community.

During the Fair I signed copies of the book at four venues: The Bookshop in Kirkby Stephen, Kendal Library, Bluebell Bookshop in Penrith and Westward Bookshop in Sedbergh. Each signing drew people in and feedback on the pictures was complimentary; however, I was most pleased by the positive way in which the book was received by the travelling community.

Kirkby Stephen auction mart holds a horse sale during Appleby Fair week, enabling travellers to sell horses alongside local horse owners. With time to spare before the signing at Kirkby, and an urge to see horses sold where my own first Fell pony, Rufus, had originally been

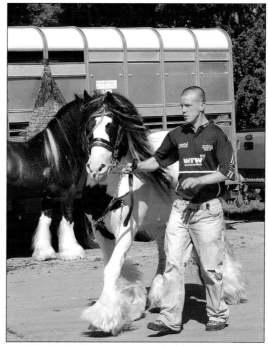

Kirkby Stephen auction mart holds a horse sale during Fair week.

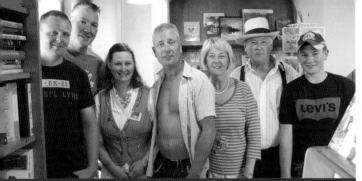

Heidi M Sands (third from left) and Barbara (bookshop owner) with a group of travellers.

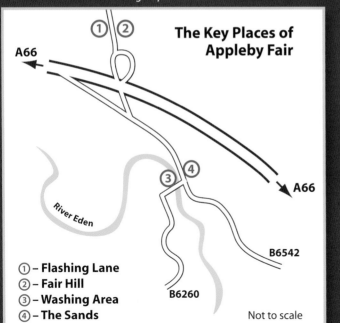

The Key Places of Appleby Fair

A66

A66

River Eden

B6542

B6260

① – Flashing Lane
② – Fair Hill
③ – Washing Area
④ – The Sands

Not to scale

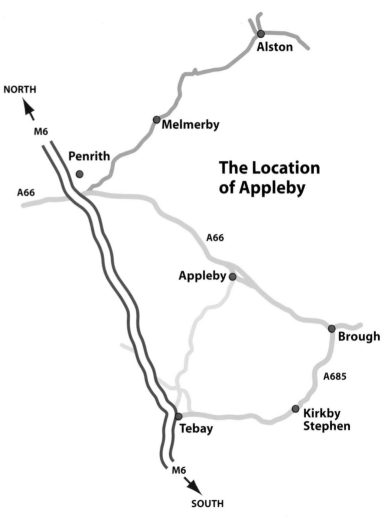

The Location of Appleby

NORTH

M6

A66

Penrith

Melmerby

Alston

A66

Appleby

Brough

A685

Tebay

Kirkby Stephen

M6

SOUTH

bought as a weaned foal by the then Field Master of the Vale of Lune Hunt, my husband and I perused the mix of horses and ponies for sale. The ringside was crammed as the bidding began and travellers from as far away as northeast Scotland vied for a space.

Easing ourselves out of the mart was not an easy task, but it had to be done in order to reach the signing on time. In the bookshop, a stream of locals waiting for signed copies was interspersed with familiar faces from the auction mart earlier that day. A man and his wife, behind whom I had been sitting, approached me to talk about the day's prices. Another man was hugely delighted to find himself within the pages of the book and yet another bought seven signed copies only to return half an hour later to buy another seven! He and his family posed with me and Barbara, the bookshop owner, for photographs (see pg 4).

At Kendal library, staff, family friends and local shopkeepers were delighted to find us on their doorstep and we experienced a similar reaction in Penrith and Sedbergh. The Penrith signing was made all the more special by two young traveller lads who I noticed were standing back from the signing table.

I asked them to come over and take a look at the book; they were not too sure saying they could not buy it, but they relaxed after I assured them it did not cost anything to look. With the book in his hand one of them told me his mate was pictured, and as he flicked through trying to find the right page he regaled me with the names of horses, owners of flat carts, highly decorated bow tops and friends and acquaintances that he knew. The detail he added to my pictures was worth more than money. The fact that he was pleased with my work meant vastly

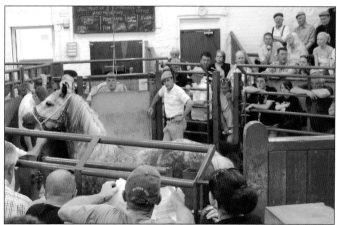

A well-filled ringside at Kirkby Stephen mart.

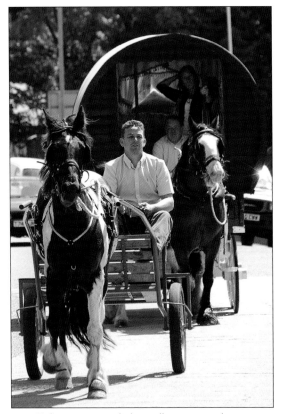

Fit horses are needed to pull wagons and carts.

more than sales figures ever could. He asked if I had been at this year's Fair and I told him I had, camera in hand, recording the horses all over again.

To some, the lives of the horses at Appleby seem far removed from those usually seen at horse shows or in fields across the UK. That may well be true, for the horses at Appleby are in fact some of the only horses in Britain today actually leading the life that a horse should. You will not find a fat horse at Appleby, and that is no bad thing. A fat horse – one whose ribs you cannot feel – is at risk of metabolic disease, among other problems. A fat horse is not a fit horse, and a fat horse cannot draw a bow top wagon or a flat cart into or around Appleby. We often forget in our modern world that horses were originally bred to work, not to spend 23 hours a day eating grass in a field or standing in a stable. They were bred to work and meant to be fed accordingly.

Today most of the horses seen in the UK are used for recreation, loved by their owners and spoiled rotten. Is this good? Or is a horse actually happier on the road, with others of his kind, moving day to day, grazing roadside grasses and keeping fit and trim? Is this not the modern equivalent of wild horses always on the move, covering huge distances each day, grazing as they go, in a herd situation?

Most of the horses at Appleby are prized by their owners. Rumour has it that some of these animals will change hands several times, often for large sums of money. It pays such owners to take the best care they can of these horses. Some will come here to purchase horses knowing that their manner and temperament will be almost perfect. There is hardly a horse at the Fair that will be traffic shy. My own first pony came from Appleby Horse Fair, bought for me by my father from a dealer who had purchased him only a couple of weeks earlier at Appleby. I will never know if he swam in the river or was flashed on the flashing lane, but I do know he was rock steady. Nothing fazed or upset him and I strongly suspect he was not really the best pony for a child. He was a ride-and-drive skewbald (brown and white) gelding, and would have been purchased quite cheaply forty years ago because coloured cobs were more than a little frowned upon. I did not mind, but I have an idea now that as I sat upon his back urging him on, he would much rather have been between the shafts, travelling the lanes, than living off the fat of the land.

Today Appleby's coloured cobs are highly sought after. They are exported across the globe to found new generations of horses far from the Cumbrian town of Appleby in Westmorland. Buyers return year after year to evaluate such horses and as long as Appleby exists the first week in June will see the sleepy town become a temporary home to a variety of equines.

Come with me to meet more horses of Appleby Fair. These beauties are 'Absolutely Appleby'.

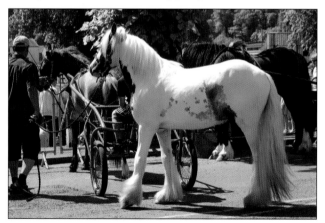

Appleby's cobs are highly sought after.

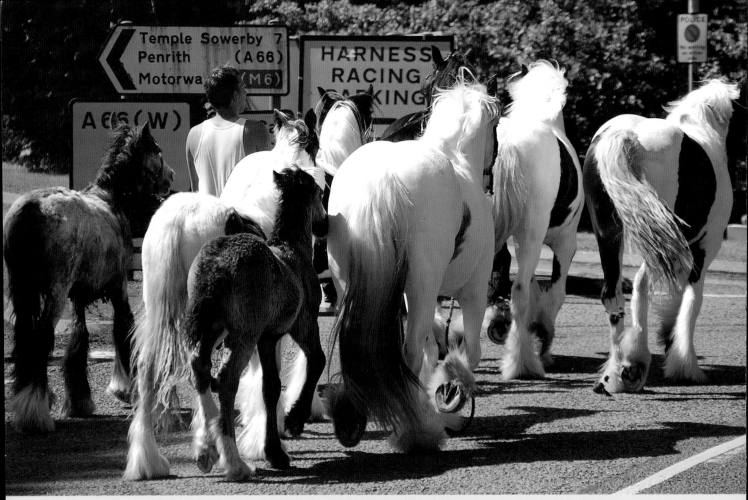

A group of horses passes the grammar school under the guidance of one man.

Absolutely Appleby

Appleby Horse Fair means different things to different people. To the travelling community it is an annual gathering: one that generations of travelling families have attended. It is a chance to get together and trade horses, stories and family history. Young travellers may meet up with friends, cousins or even potential suitors, for many relationships begin or are forged at Appleby.

For non-travellers it may be about the spectacle or the horses – for nowhere else in Britain do so many coloured horses come together. The tradition, the slow-moving Romany caravans and a seldom-offered chance to savour a generally slower pace of life also add to the allure. The Fair is a peek into an occasion most of us will never otherwise see; a chance for travellers and 'gorgers' – non-travellers or country folk – to share in the experience.

Above all it is a unique event and defines the normally quiet country town of Appleby as central to gypsy and traveller culture. Long may the Fair continue.

Appleby is the old county town of Westmorland. The county was amalgamated with Cumberland to form Cumbria in the 1970s.

It is no secret that Appleby Fair has been a big hit on the small screen.

For those who have never been to Appleby before, direction abounds.

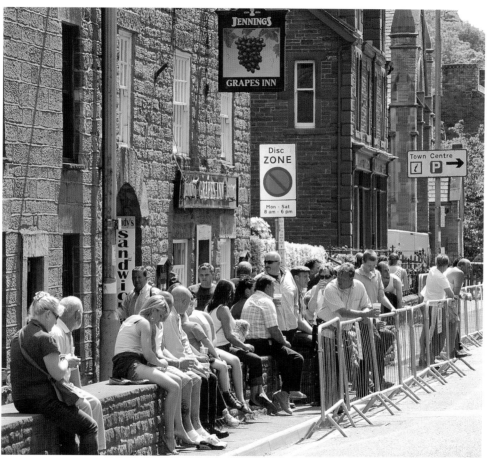

Crowds gather outside the Grapes Inn to watch the horses and wagons pass by.

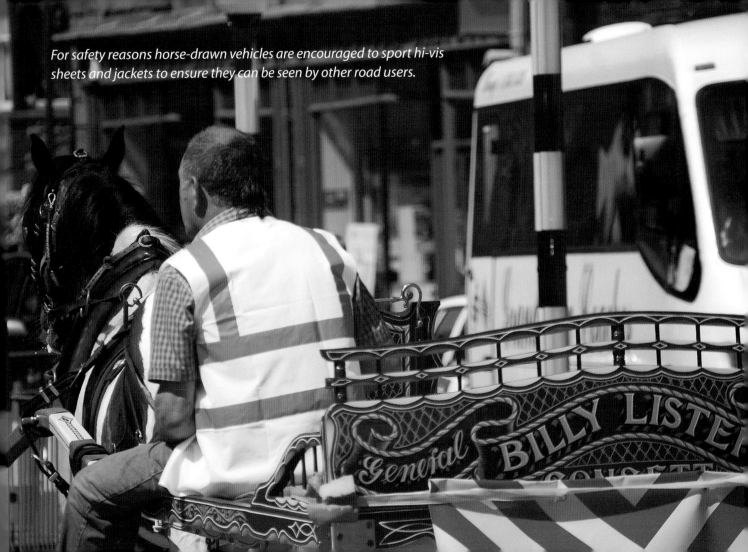

For safety reasons horse-drawn vehicles are encouraged to sport hi-vis sheets and jackets to ensure they can be seen by other road users.

An intricately decorated flat cart with carefully picked out embellishments in gold, red and black.

Families sit on the grass banks of the river Eden to see the horses being washed and prepared for potential buyers.

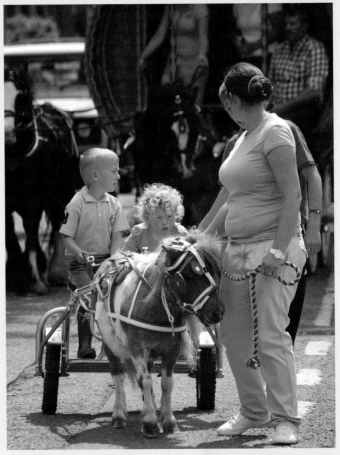

Children are encouraged to be part of things in the travelling community; here a helping hand is on the reins of a Shetland turnout.

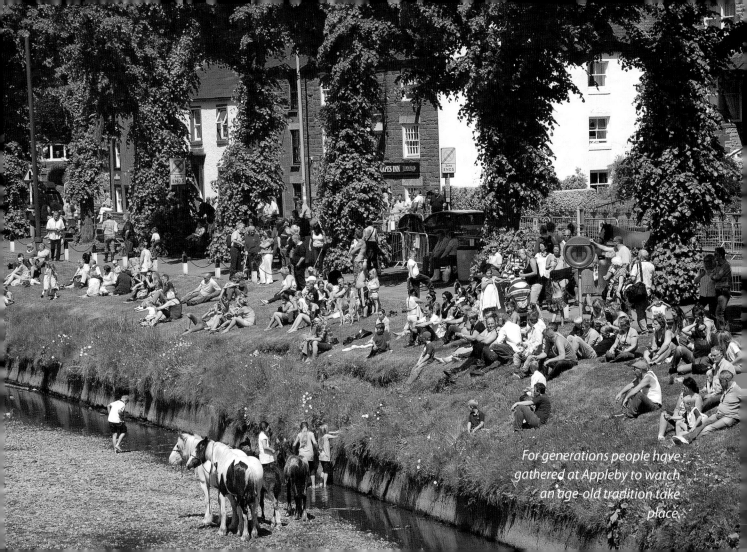

For generations people have gathered at Appleby to watch an age-old tradition take place.

Untrimmed, this horse sports an impressive moustache, which only adds to his character.

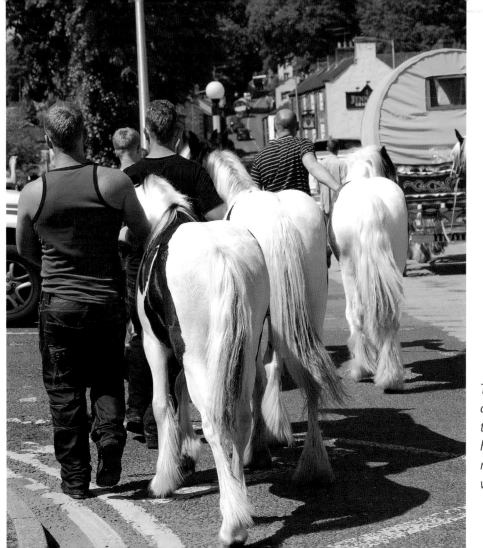

Three youngsters are led through town. Unbroken horses are often moved in this way.

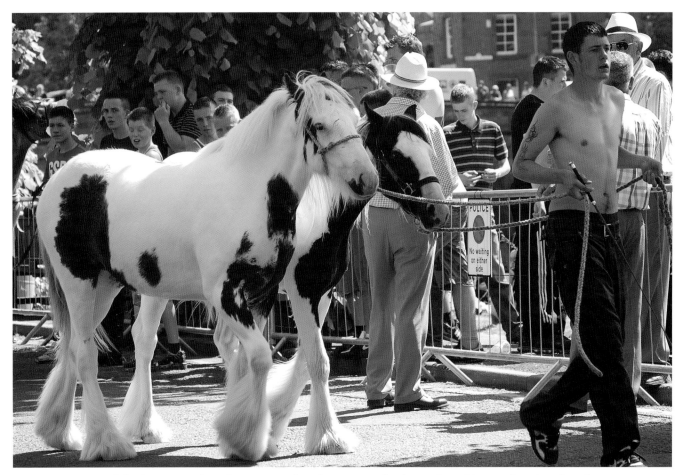

Many of the horses are barefoot – meaning they are unshod – and working well on hard surfaces.

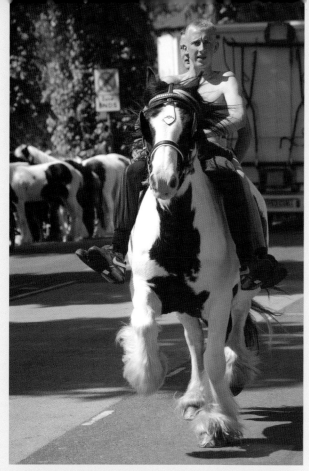

Two boys ride one behind the other on a single horse. The blinkered bridle indicates that this horse may be capable of being driven as well as ridden.

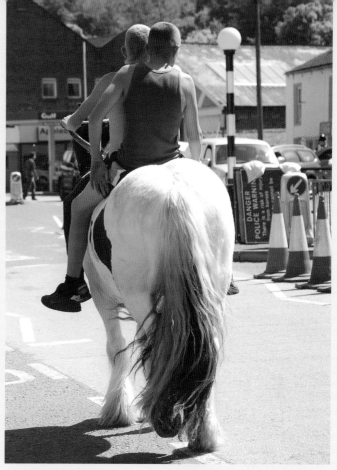

Trotting bareback takes skill and good balance.

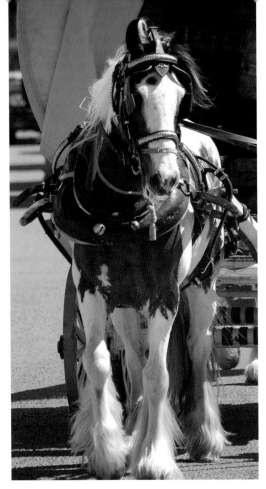

A nice little skewbald pony brings a vardo into Appleby.

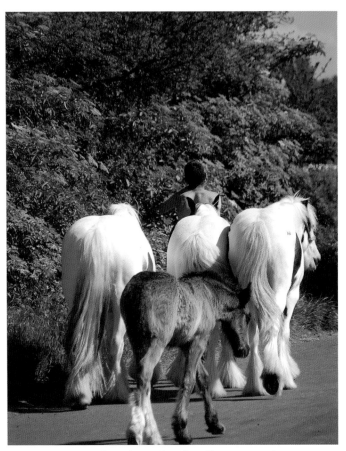

It can be a long day for all concerned.

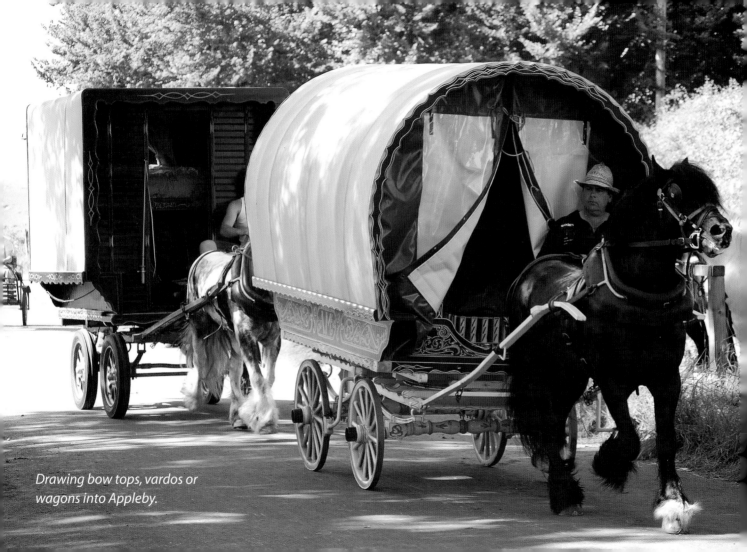

Drawing bow tops, vardos or wagons into Appleby.

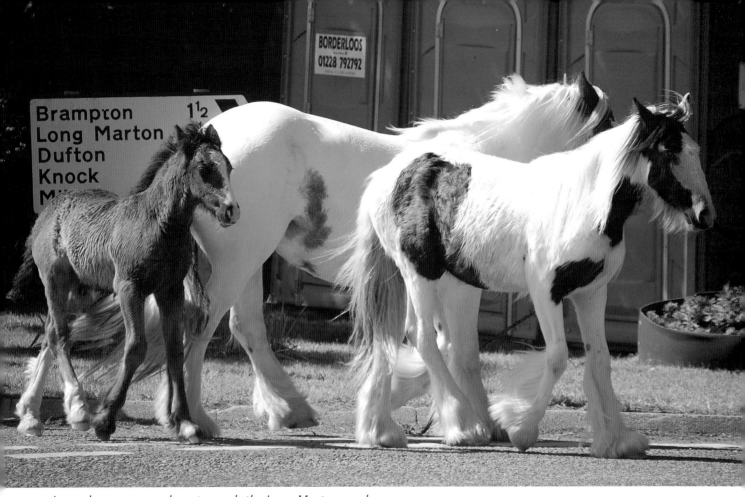

Loose horses move along towards the Long Marton road.

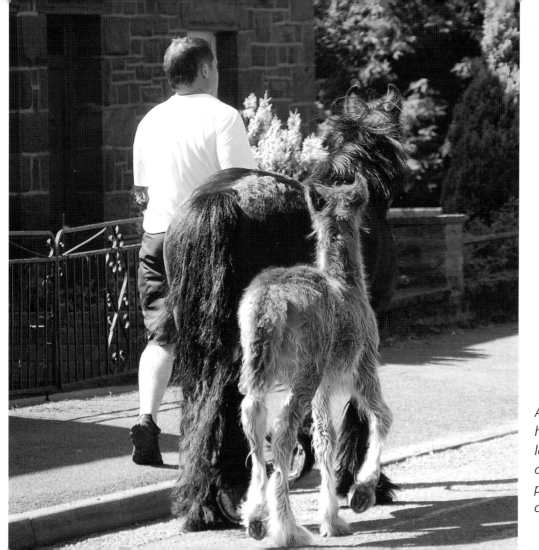

A mare and her foal are led in front of Appleby's picturesque cottages.

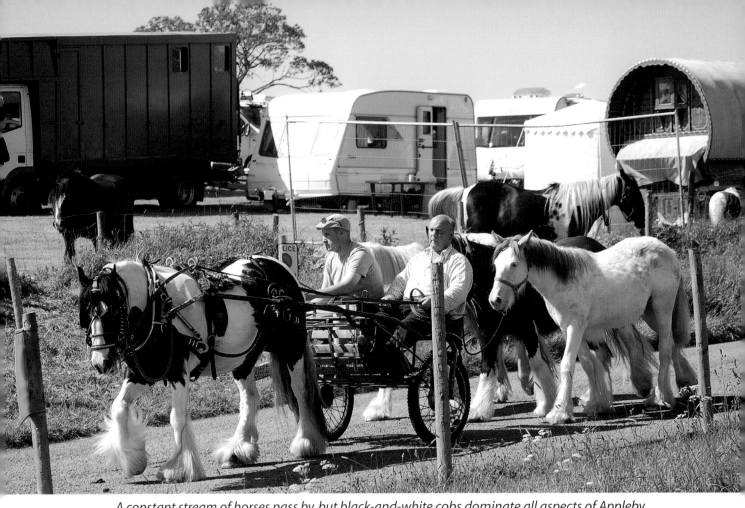

A constant stream of horses pass by, but black-and-white cobs dominate all aspects of Appleby.

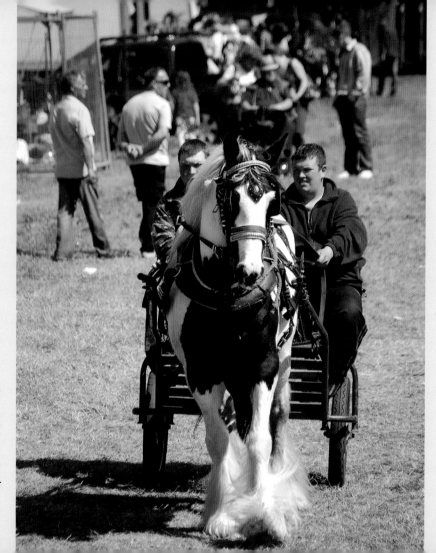

Control is of the utmost importance when passing other horses and people on the ground. There is no doubt that high standards of behaviour are expected.

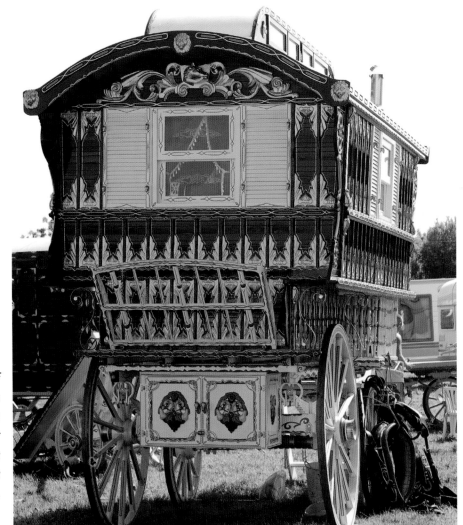

All manner of horse-drawn vehicles are on show. High rear wheels are indicative of the Reading wagons.

Colour is all-important on travellers' wagons as can be seen from the craftsmanship and work that goes into decorating them.

The horse is hugely symbolic to the travelling community and features heavily on the exterior of their living wagons.

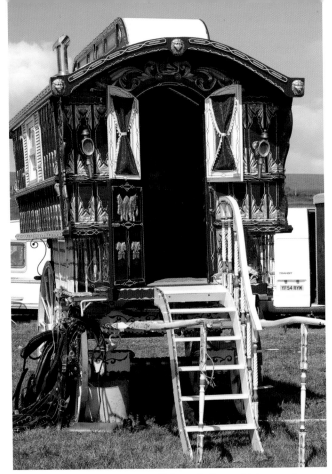

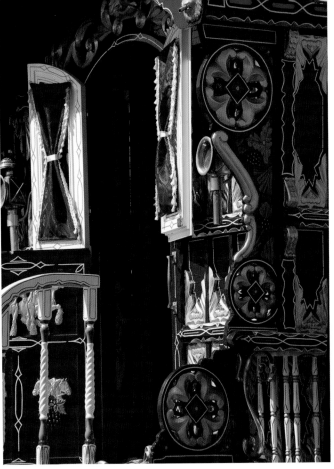

Living wagons were traditionally bought by or given to a newly married couple by family and would stay with the couple throughout their lives.

Romany art is a celebrated form of folk art that was developed in the 1800s; today it is much admired and highly prized.

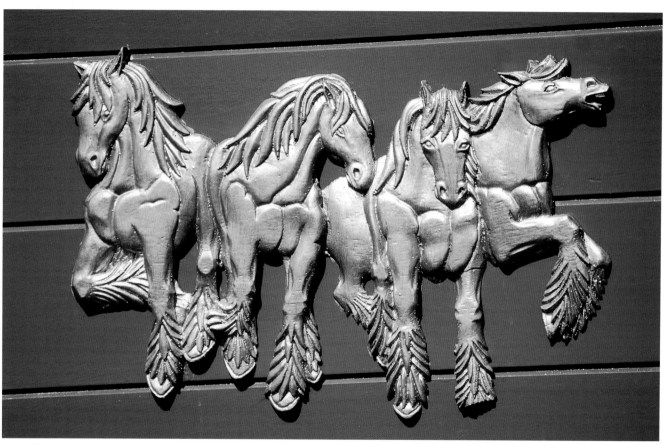

The most elaborate carvings are to be found on Romany living wagons. Here a group of horses are depicted and elsewhere birds and scrollwork may be seen.

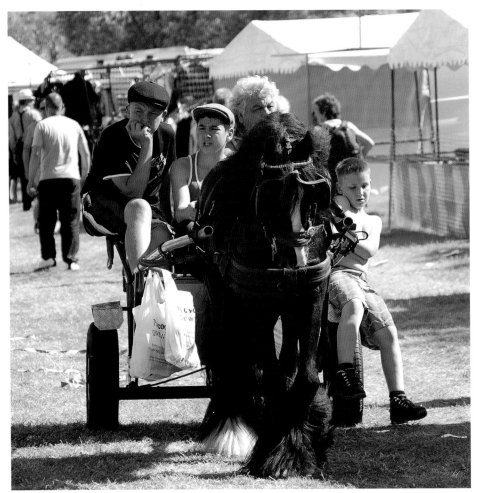

Across the generations horses are an all-important element of life for travellers.

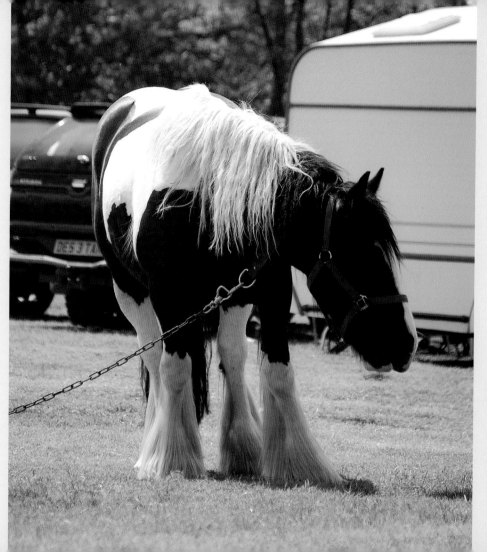

A traditional heavy black-and-white cob tethered and waiting to play his part in the Fair.

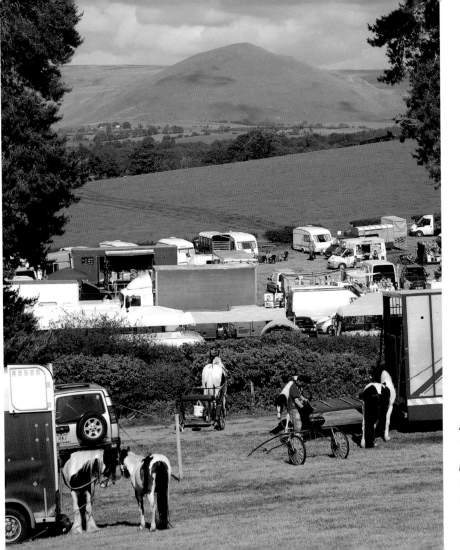

A pastoral scene at Appleby where peace reigns, horses wait patiently and the Cumbrian views form a perfect backdrop to this ancient gathering.

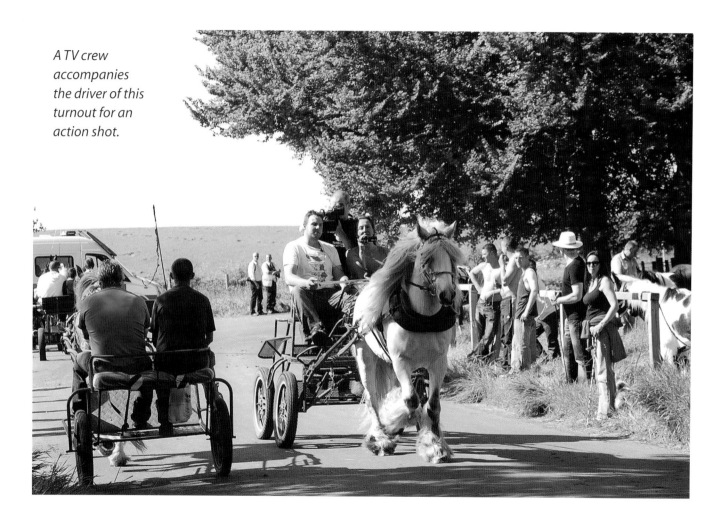

A TV crew accompanies the driver of this turnout for an action shot.

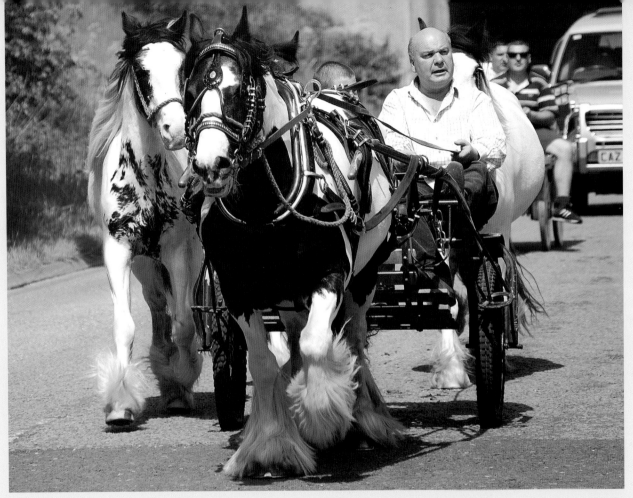

A decent harness can really set a cob off to its best advantage.

On the Move at Appleby

Almost everything is on the move at Appleby. From horses being led in hand – often in strings – to vardos, gypsy wagons, exercise vehicles, traps and sulkies, horses are more often than not, the only way to travel.

Young men attract the attention of onlookers by speeding along, while the older generation slowly take things in their stride. 'Mind yer backs' is a common cry at Appleby, advising the wary of the approach of horses or horse-drawn vehicles.

Decorated living wagons, often with whole families on board, move sedately, while lighter wheeled gigs pass by easily. Having travelled many miles to reach Appleby, heavy feathered cobs pull into their allotted spaces ready to rest and relax.

Taking the reins at Appleby are an array of drivers from the experienced to novices operating under the guidance of older horsemen. For many this is a chance to follow in the footsteps of generations of their families: a connection with the past.

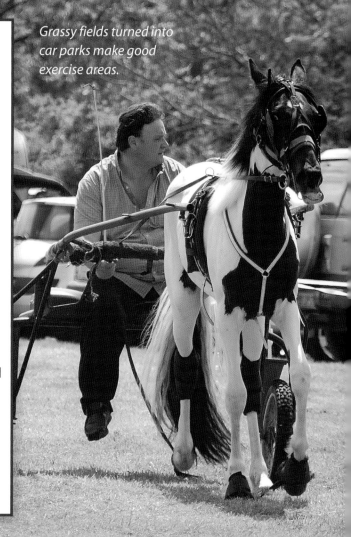

Grassy fields turned into car parks make good exercise areas.

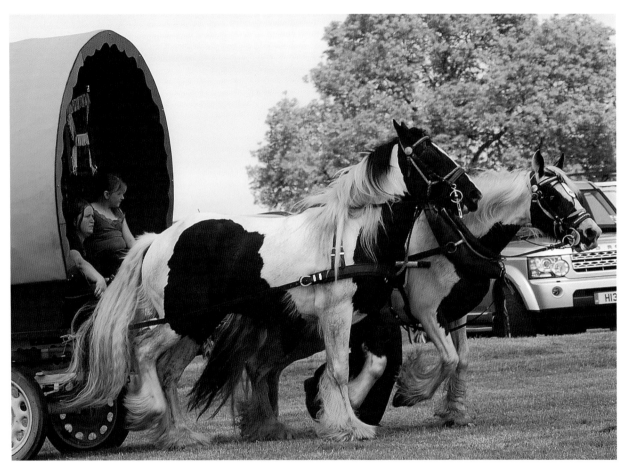

Two horses are sometimes needed to ease the burden.

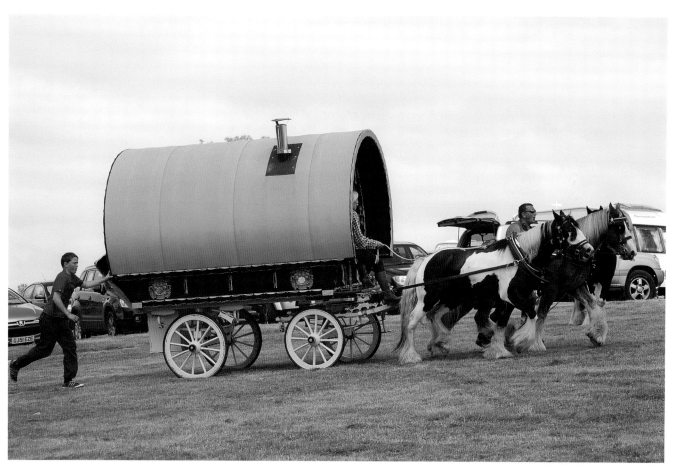

The last pull before unharnessing at Appleby.

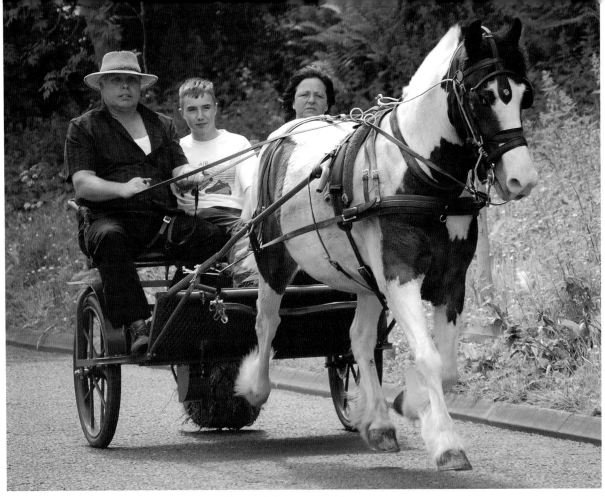

Maintaining a spanking trot.

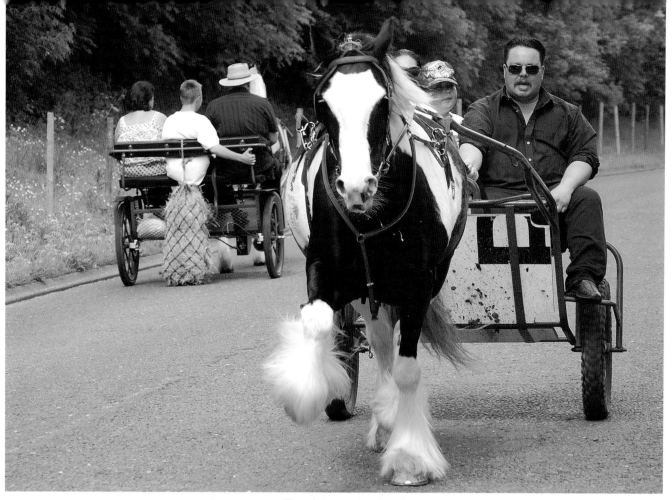

Two-way traffic of the equine kind.

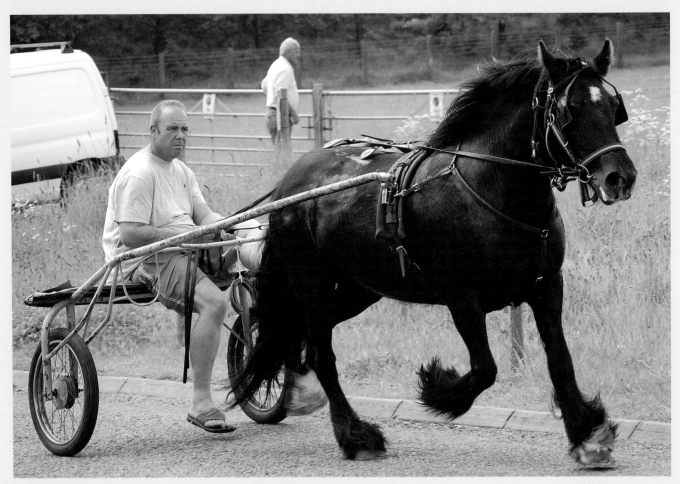

A good Fell type trots out on the tarmac.

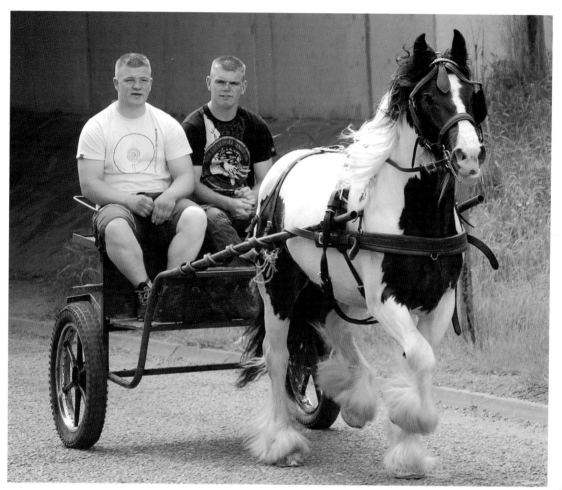

A smart cob emerges from under the bridge and heads towards the town centre.

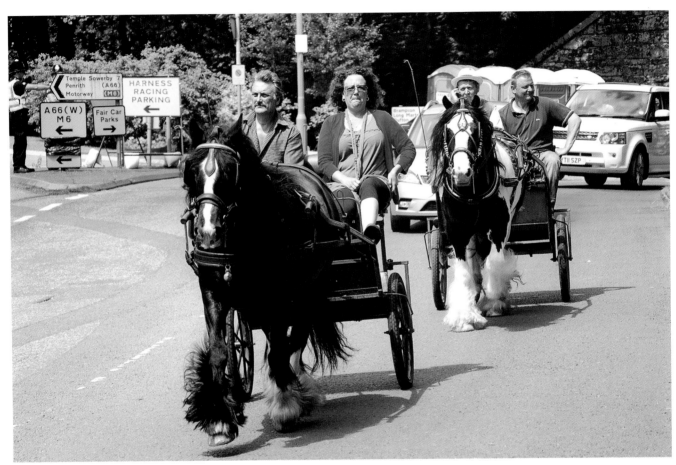

Horse-drawn transport changes little from year to year.

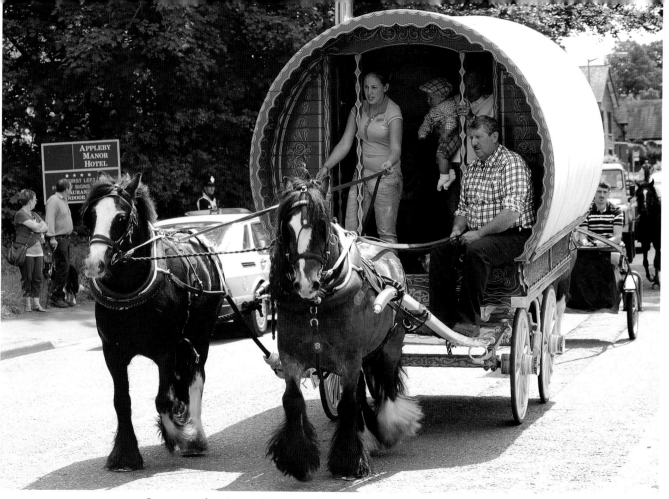

Bow tops dominate. Many are beautifully decorated by craftsmen.

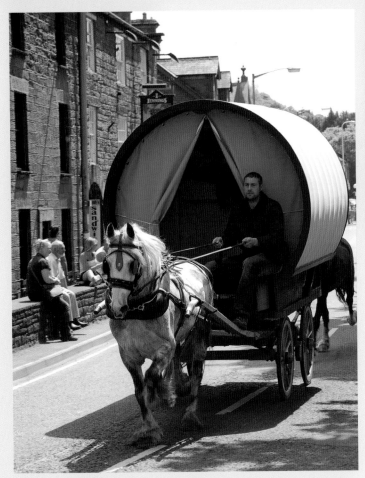

Horses come in all colours at Appleby; here a grey cob gets ready to tackle the hill out of the town.

Extra horses are often tied to the rear of the wagon.

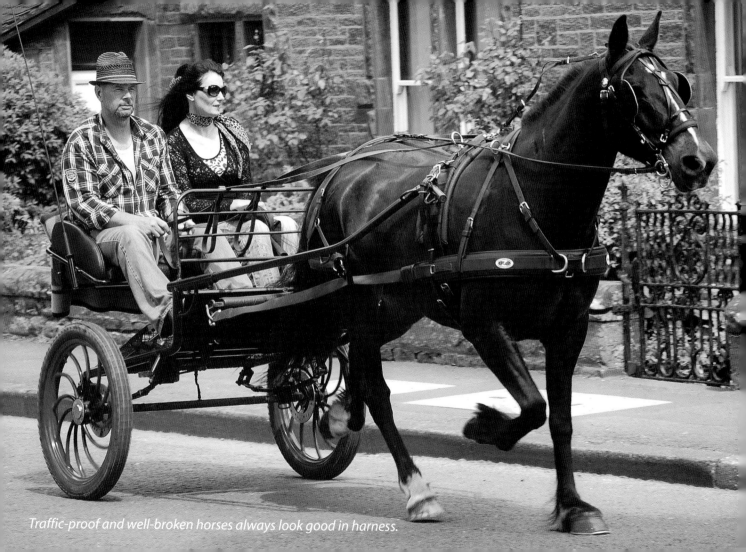

Traffic-proof and well-broken horses always look good in harness.

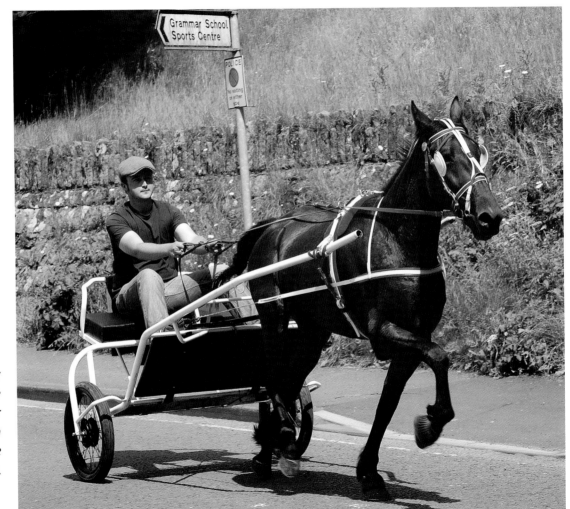

Almost every kind of equine and all manner of horse-drawn vehicles can be seen at Appleby.

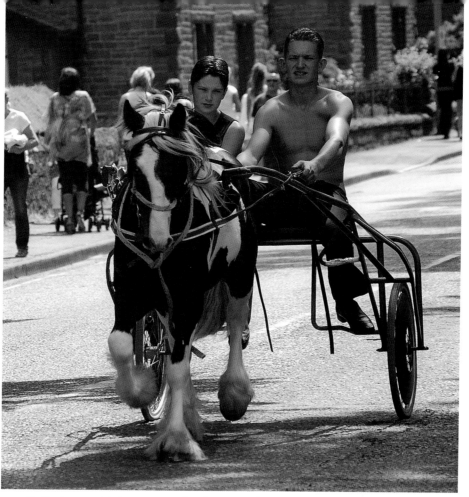

Sulky type vehicles can reach a fast pace but require a lighter built horse.

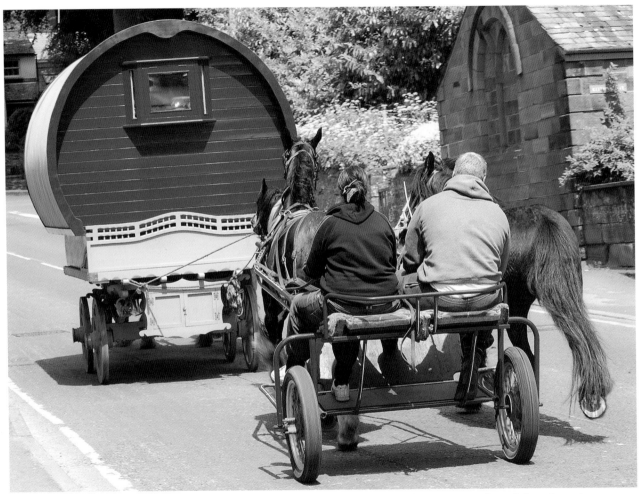

Etiquette and manners allow for faster vehicles to overtake larger slower ones where it is safe to do so.

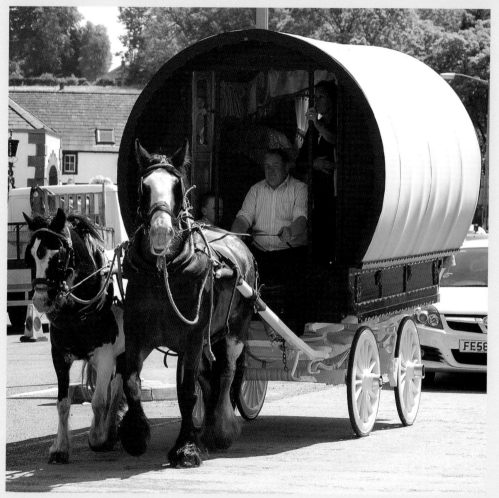

A beautiful living wagon makes a turn at The Sands.

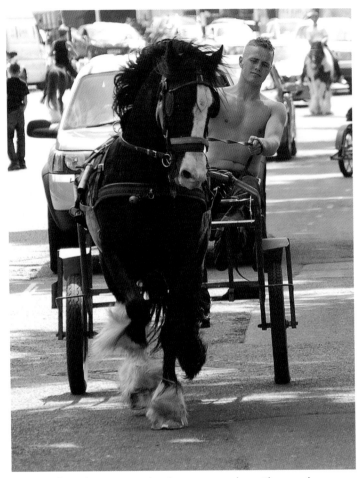

Leaning out to check progress along the road.

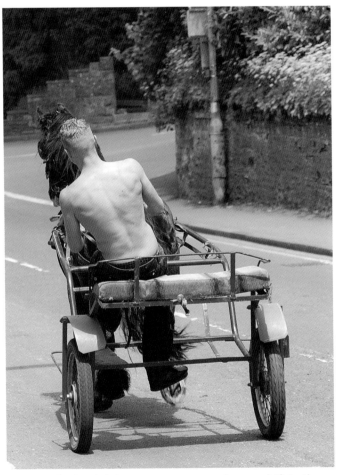

From the back it becomes apparent how a shift in the driver's weight can alter the position of the vehicle.

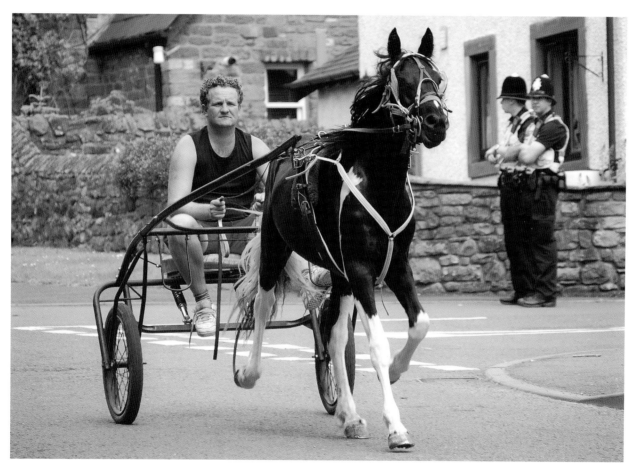

A police presence keeps accidents to a minimum.

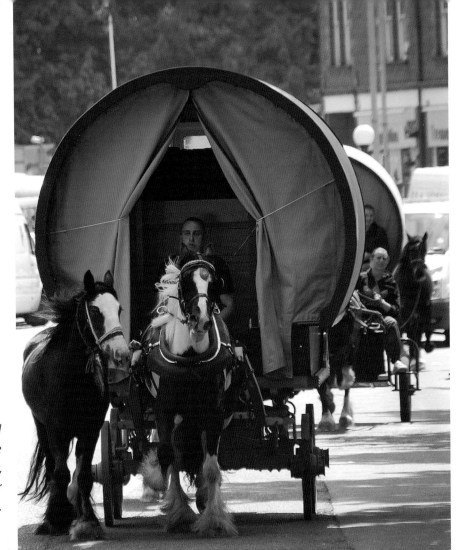

Canvas- covered wagons arrive at Appleby, coming in over the river Eden.

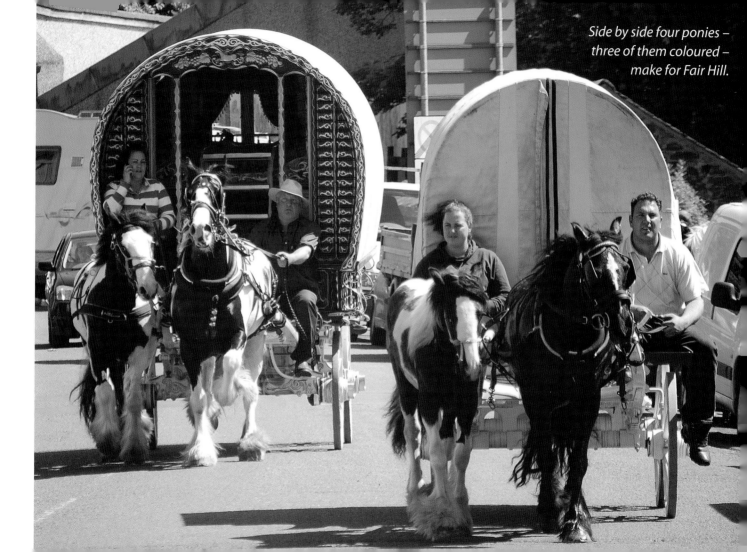

Side by side four ponies –
three of them coloured –
make for Fair Hill.

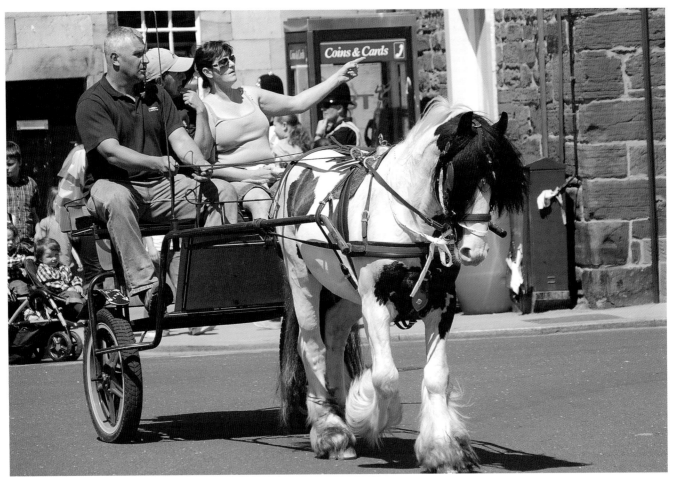

This attractive turnout passes by Appleby's sandstone buildings.

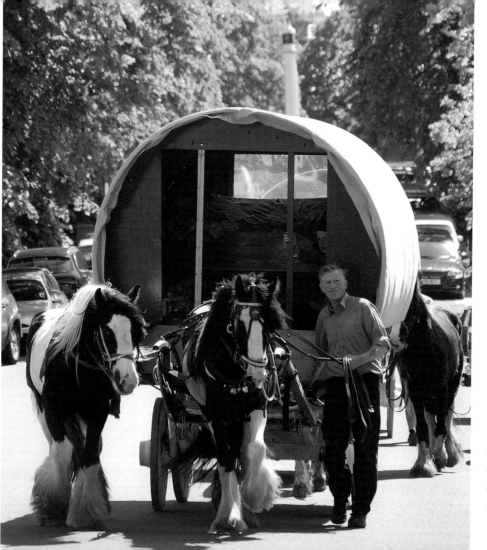

Keeping control on the approach to the bridge.

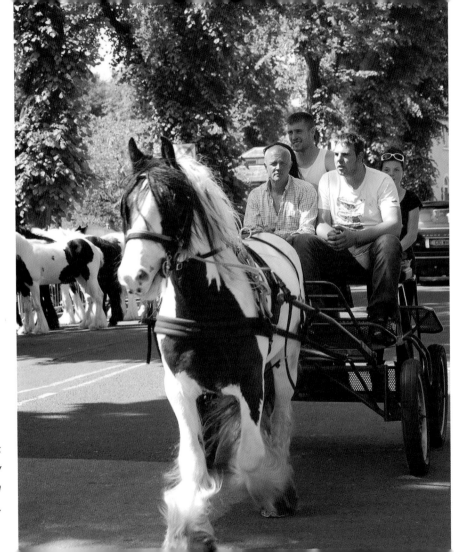

Appleby's cobs show steady nerves when being driven.

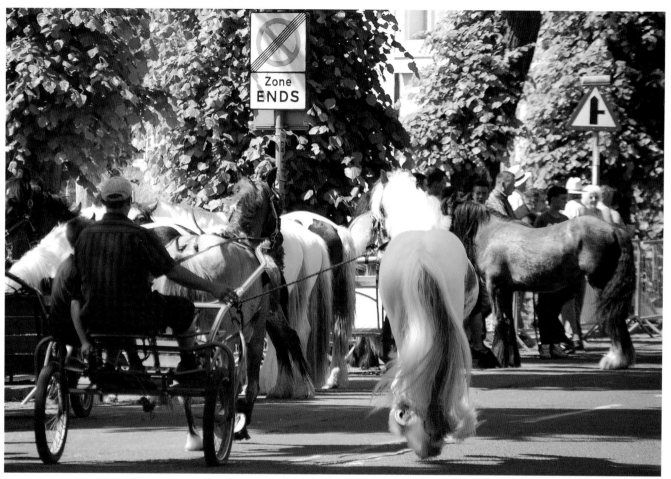

Horses stand at The Sands while owners chat, swap tales or do business.

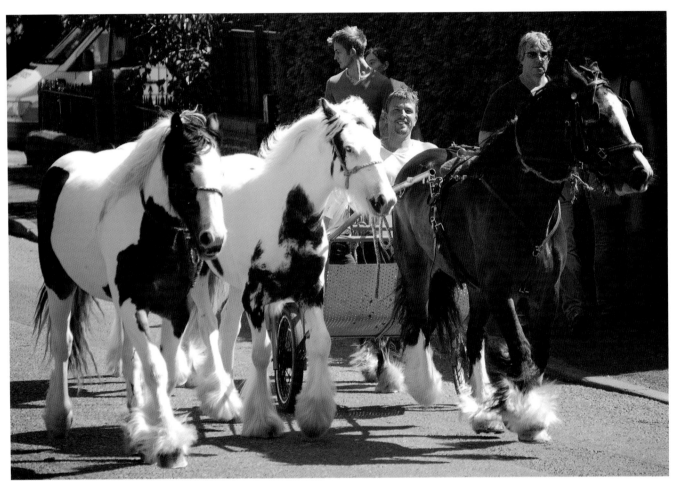

One single man can control several horses without incident.

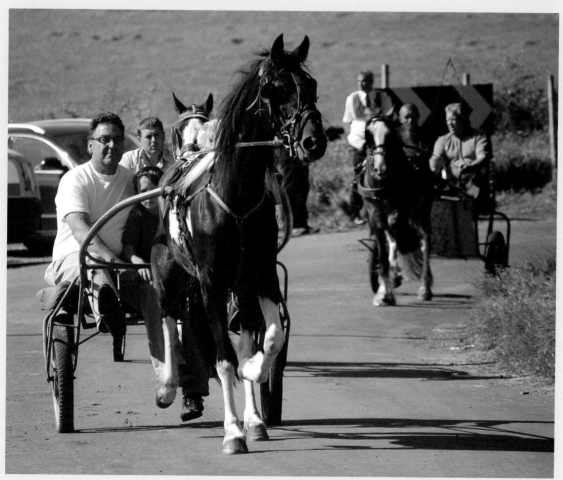

Trotting along the flashing lane.

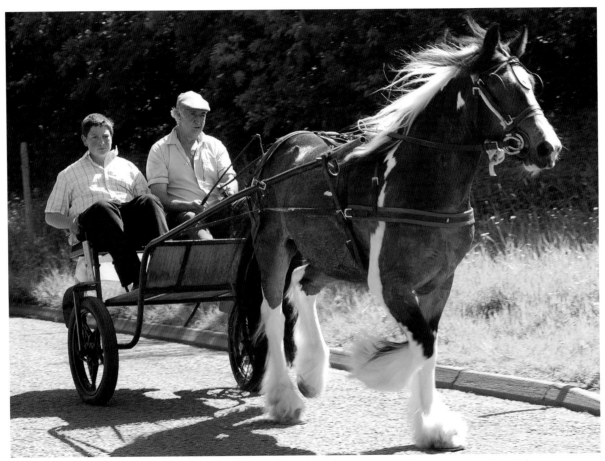

An exercise cart makes the perfect vehicle in which to enjoy driving along Appleby's lanes.

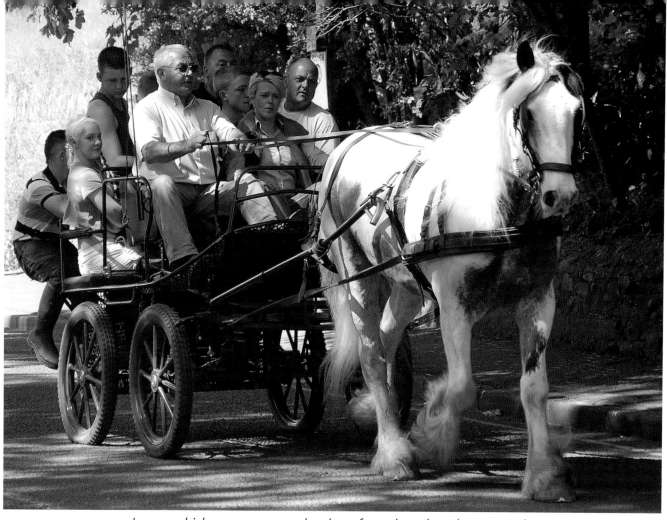

Larger vehicles can accommodate lots of people and need a strong cob.

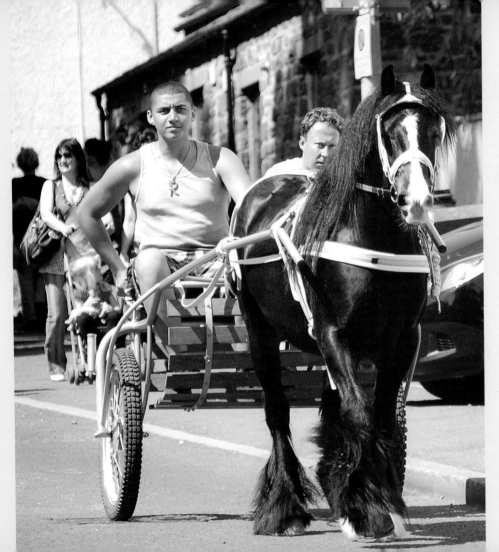

This handsome turnout heads towards the Eden.

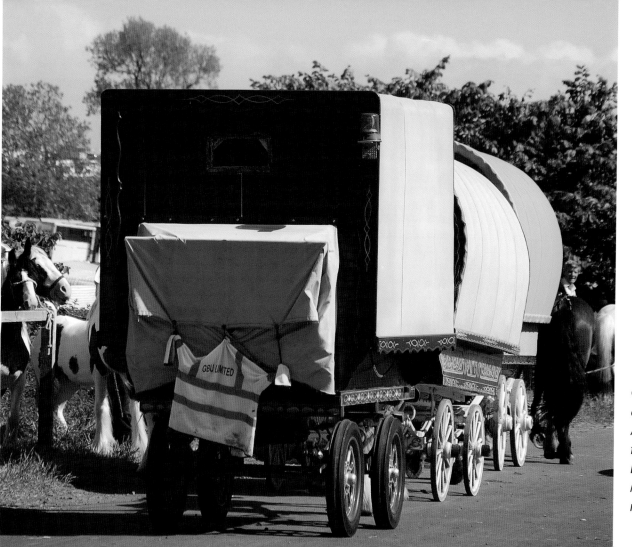

Caravans arrive at Appleby from the Long Marton road.

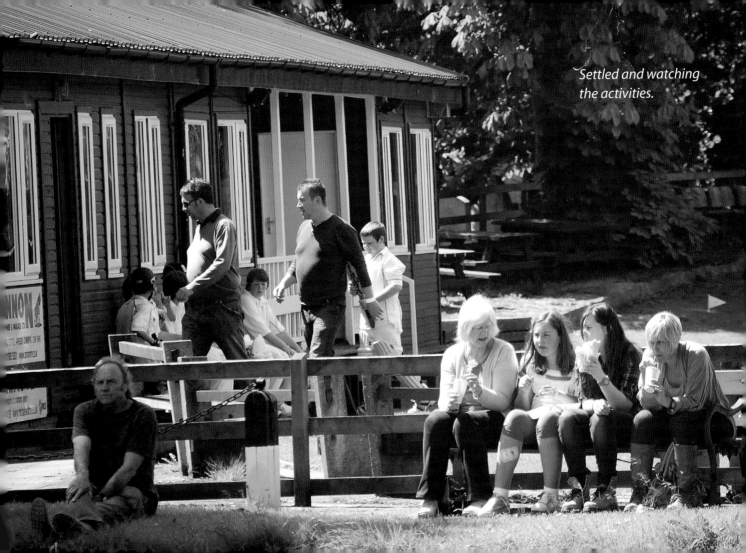

Settled and watching the activities.

Paradise in Eden

The river Eden begins life as a trickle high above Mallerstang, weaving its way through the Eden valley and eventually spilling out into the Solway close to Carlisle.

Halfway along its course the Eden creates its own special paradise at Appleby. This paradise hasn't gone unnoticed by the travelling community who have availed themselves of the pools and shallows, using them to wash and prepare their horses for generations.

A horse ramp has been created at The Sands to enable safe entry into the river. In bad weather, when the water is high, access is sometimes denied on the grounds of safety, but when the sun is out, the deep pools near the furthest bank entice the brave to swim their horses.

At The Sands, horses are cleaned and refreshed with washing-up liquid often replacing shampoo. Ultimately, this little slice of paradise is a place to drink and cool down at journey's end.

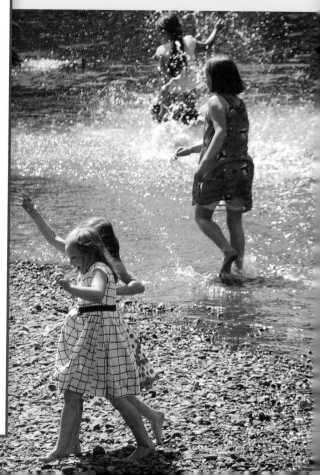

Children play and enjoy the river alongside the horses.

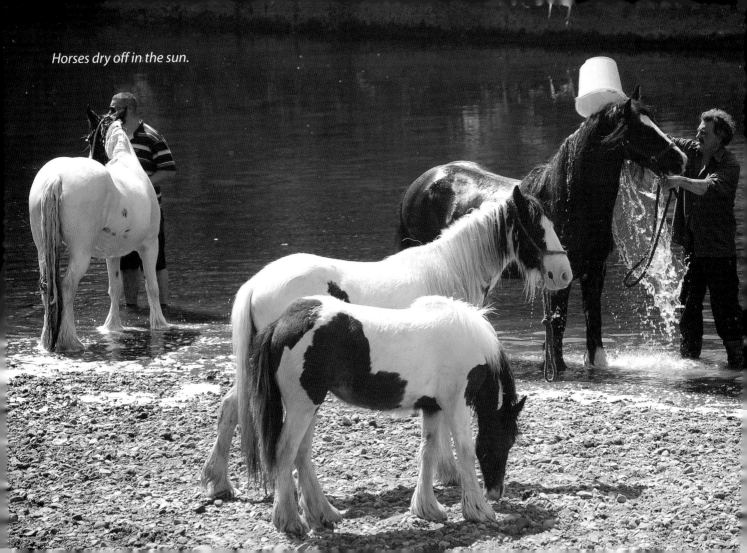

Horses dry off in the sun.

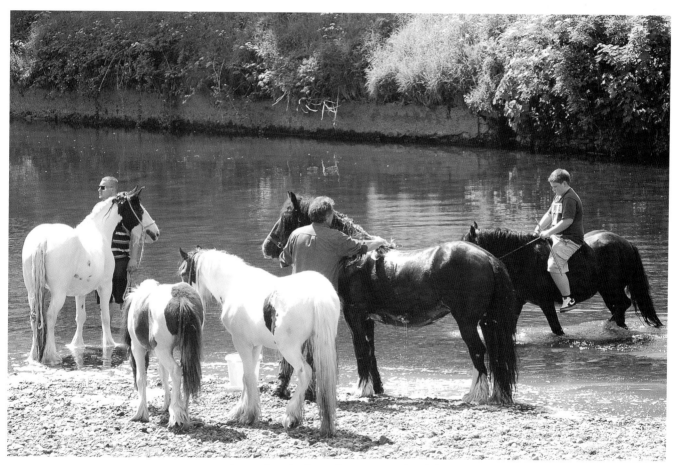

A gentle, relaxing afternoon at Appleby.

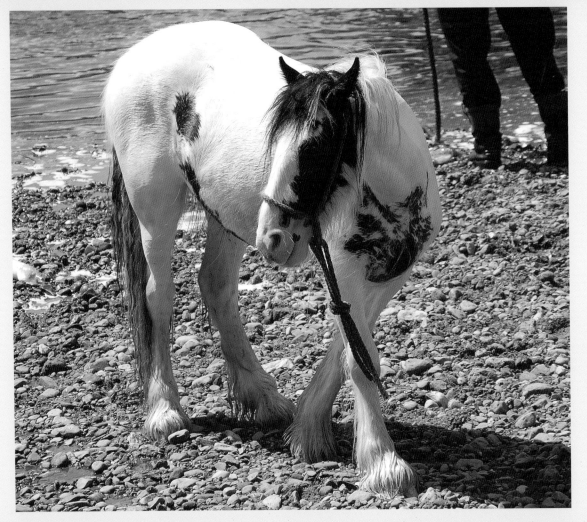

There is often no need to tie up horses if they are quiet and well behaved.

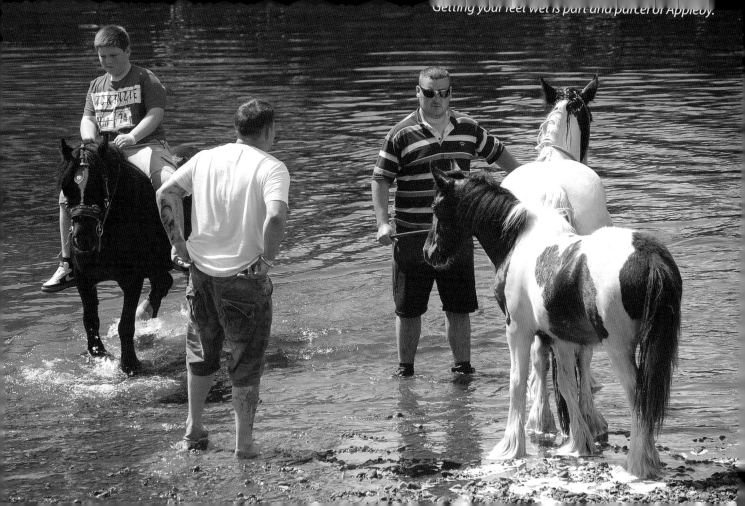

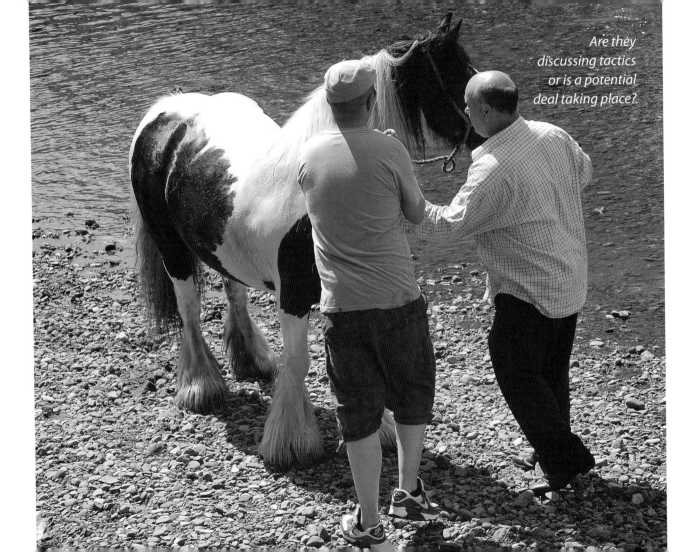

Are they discussing tactics or is a potential deal taking place?

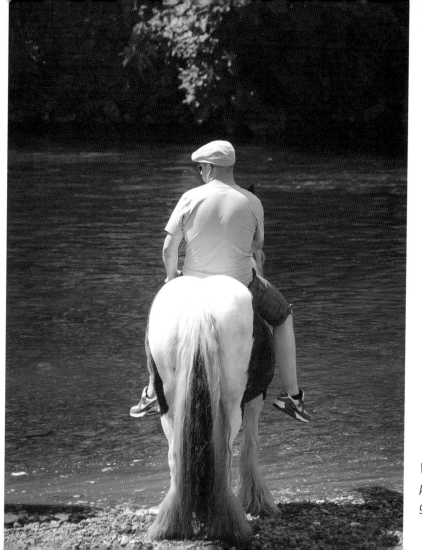

Weighing up the pros and cons of going in.

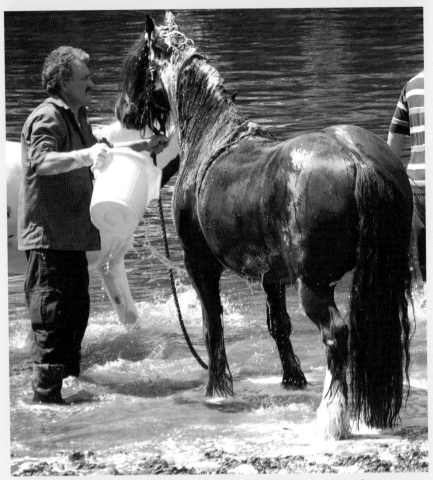

It is important to make sure all the bubbles are washed out of the horse's coat.

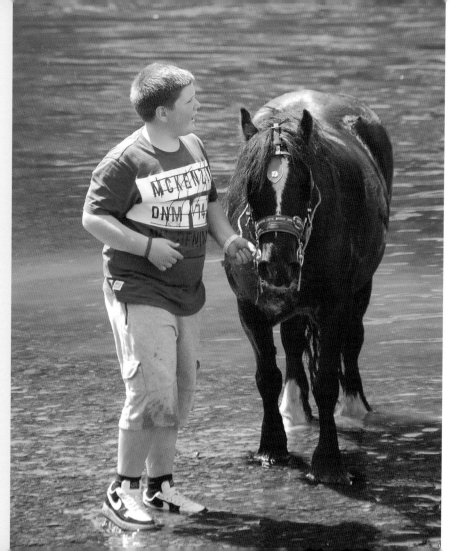

A young man waits with his pony.

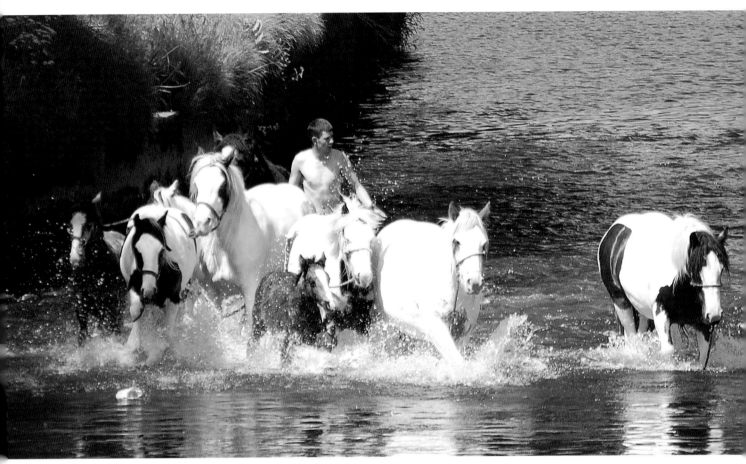

A band of horses set off…

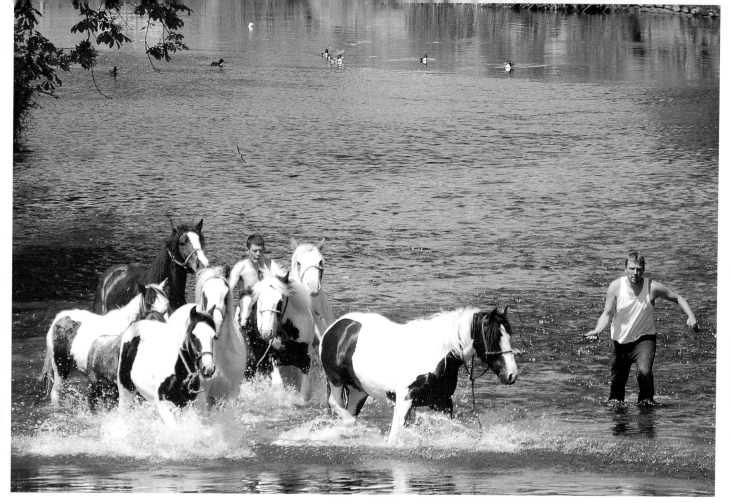

…move as one…

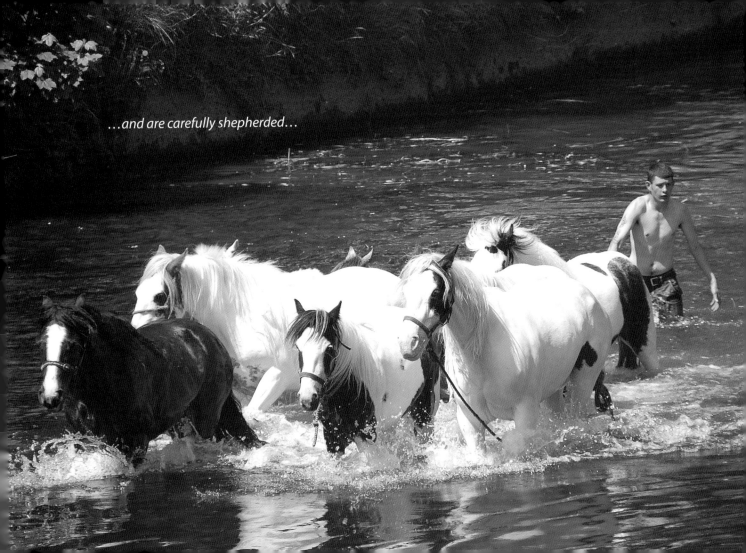

...and are carefully shepherded...

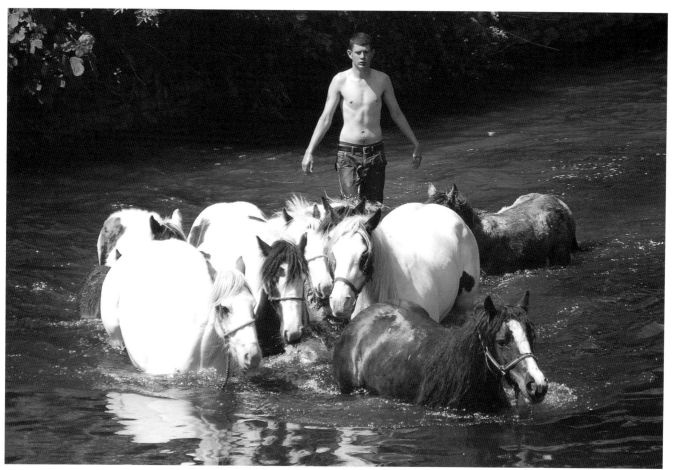

…until swimming.

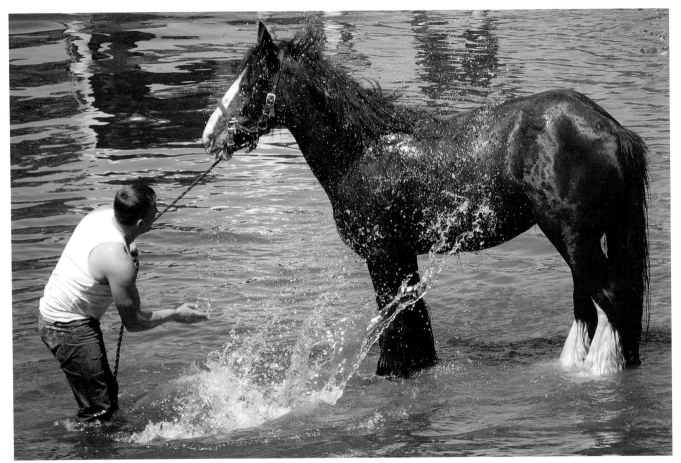

Splashing in place of bucket rinsing.

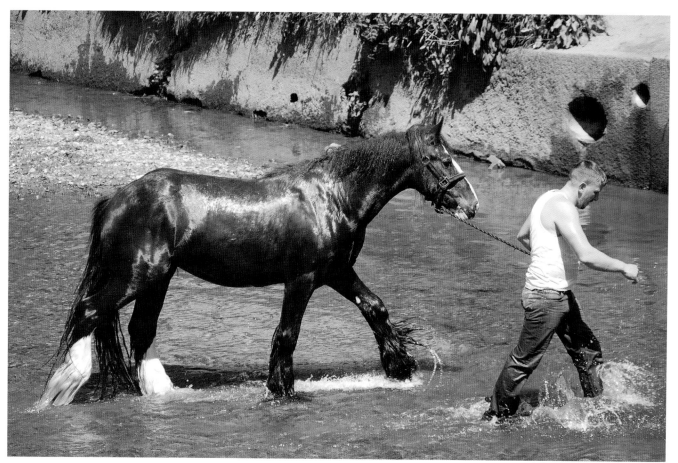

Heading towards the ramp.

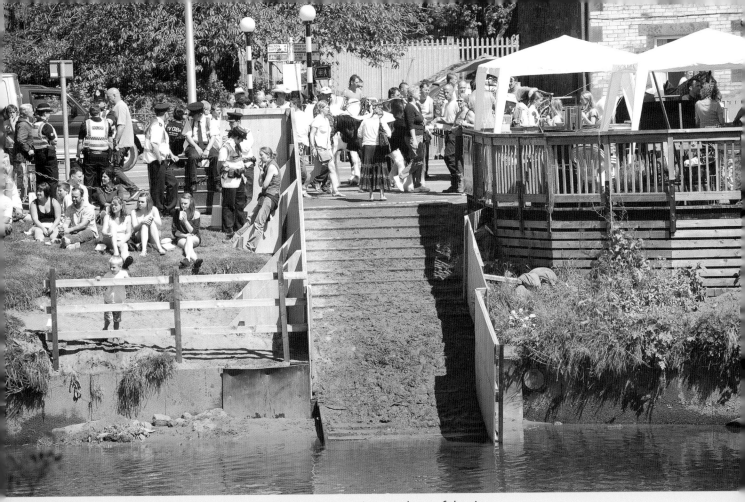

The horse ramp into and out of the river.

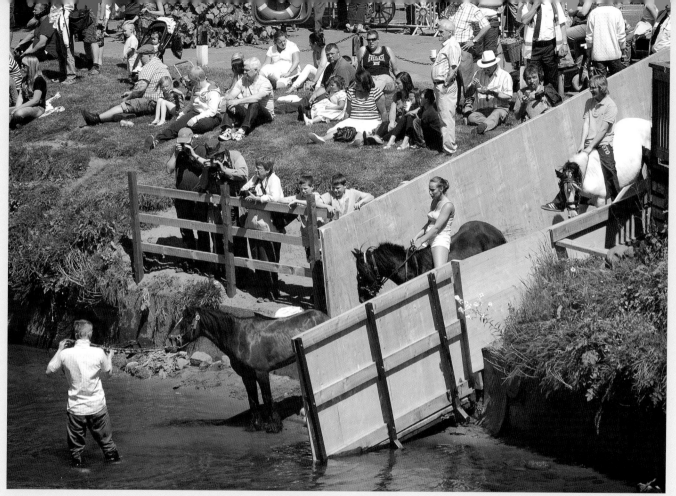

Coming down the ramp.

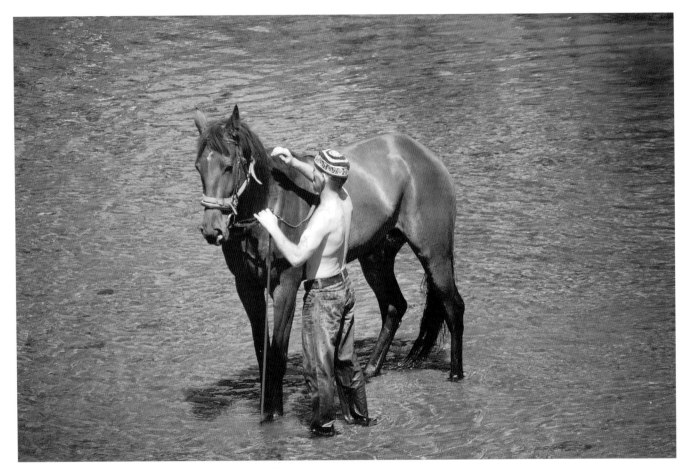

Ready to mount and swim.

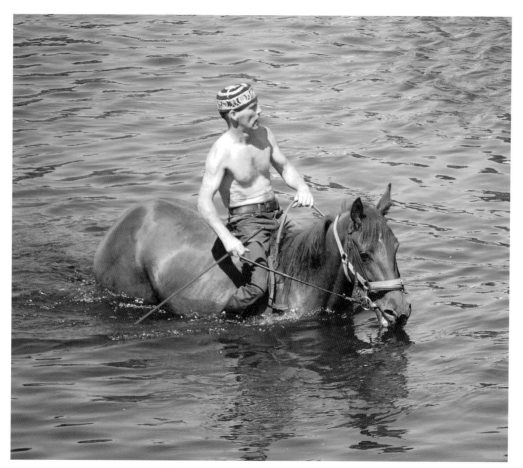

Feet only just touch the bottom of the river bed.

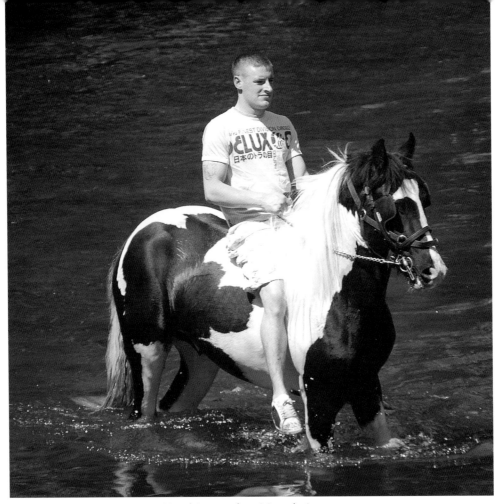

Watching and waiting their turn.

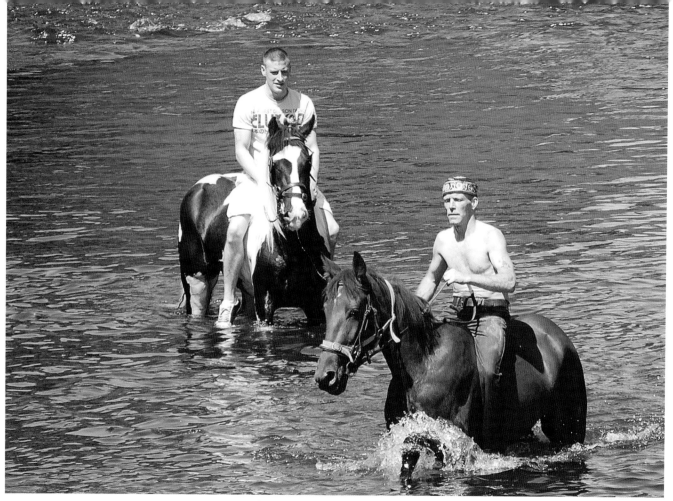

Making way for others in the water.

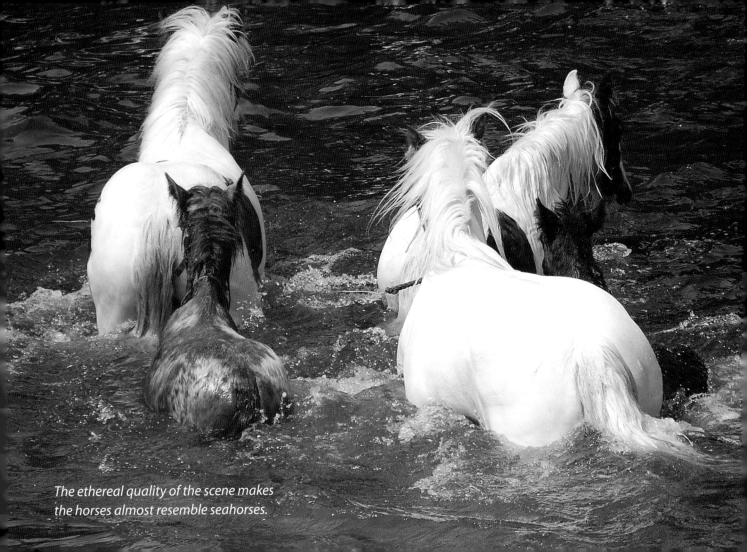

The ethereal quality of the scene makes the horses almost resemble seahorses.

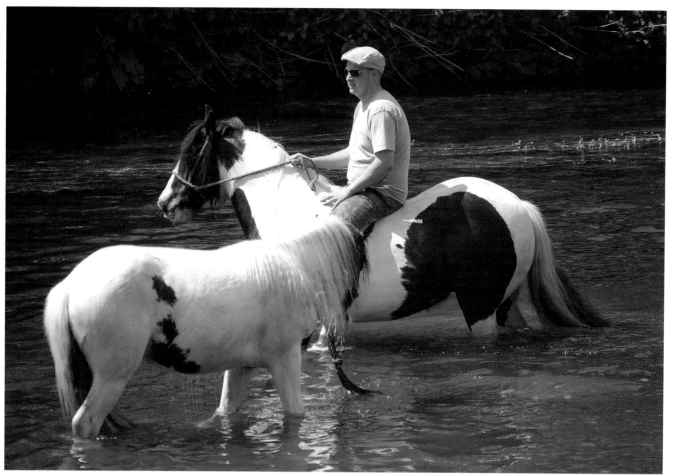

Taking to the water.

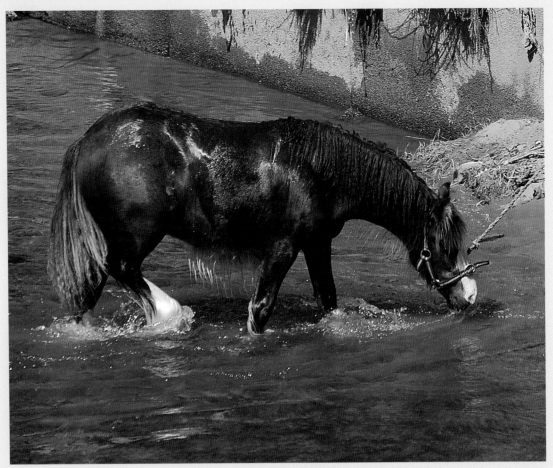

Having a well-earned drink.

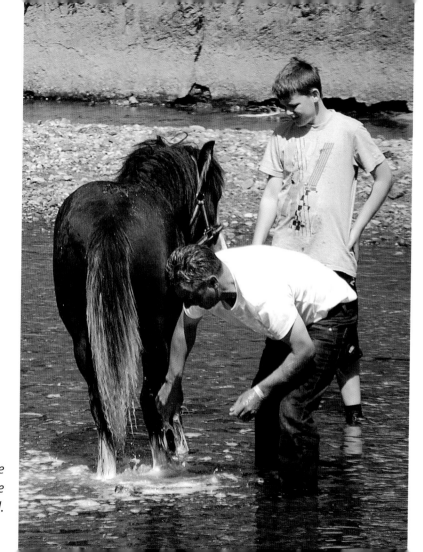

Making sure the back legs are also washed.

The low cross by the cloisters at Appleby, where many horses pass by each year.

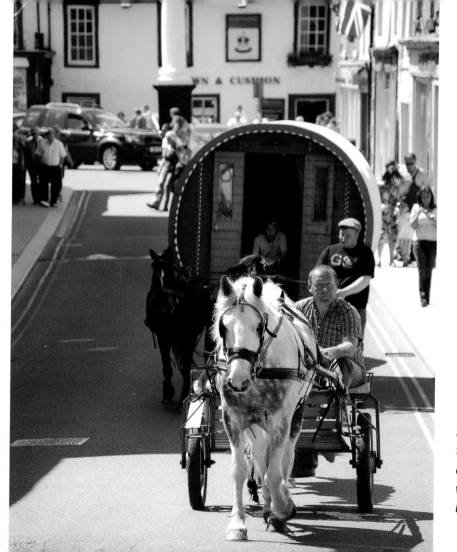

Driving onto the bridge as others are washed below.

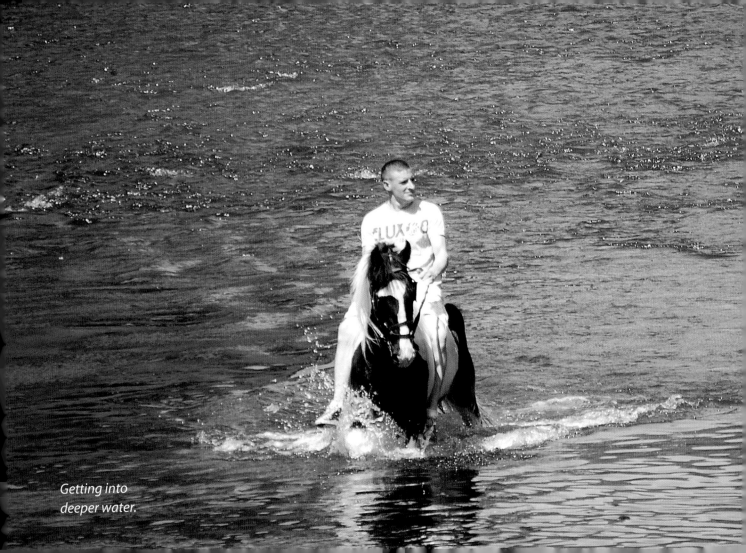

Getting into deeper water.

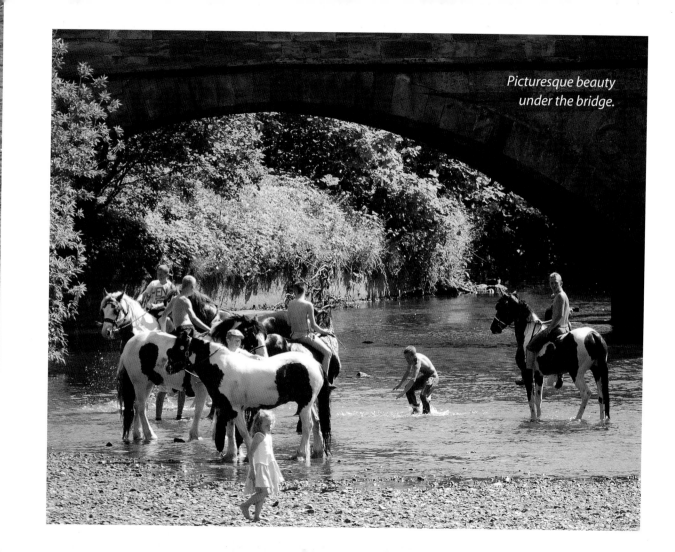

Picturesque beauty under the bridge.

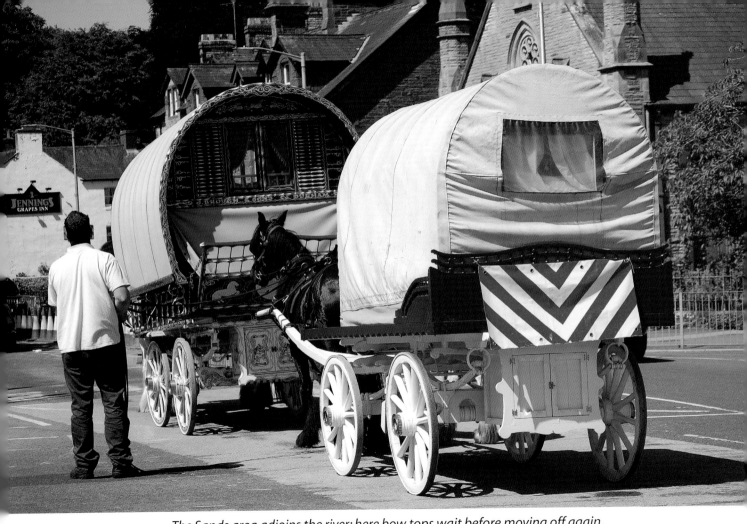

The Sands area adjoins the river; here bow tops wait before moving off again.

A young man and his horse head towards The Sands.

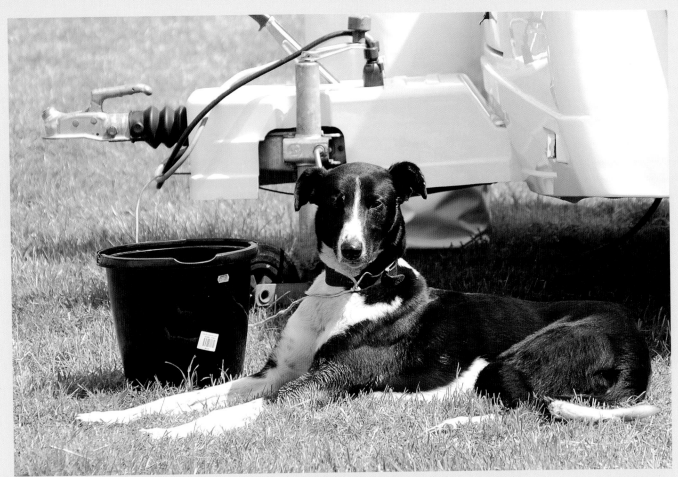

Even dogs need time out.

Restful Moments

For the most part Appleby Fair is all hustle and bustle but there are quiet corners where restful moments can be had.

Wide grassy verges accommodate tethered horses and ponies; a few grazing quietly, others taking a well-earned nap. Some of the horses are tied to rails and some of the mares have foals, often only days old. Foals are delightful at the best of times but at Appleby they seem even more so.

Horses often indulge in mutual grooming and find solace in each other's company while waiting for their owners to return. Even in the busiest areas peace and tranquillity exist.

With its sandstone cottages and wealth of history Appleby is a beautiful old country town. Much of that history includes the Fair and throughout the year – long after the horses have gone – visitors seek out the familiar names of Fair Hill, The Sands and the Flash: areas where peace has been restored.

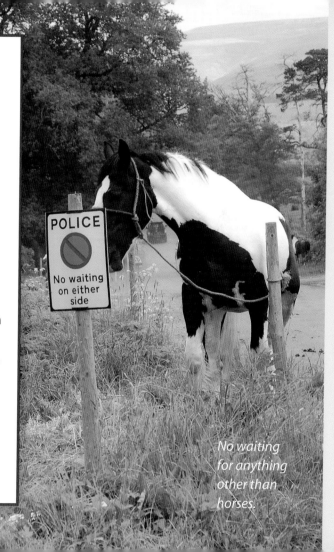

No waiting for anything other than horses.

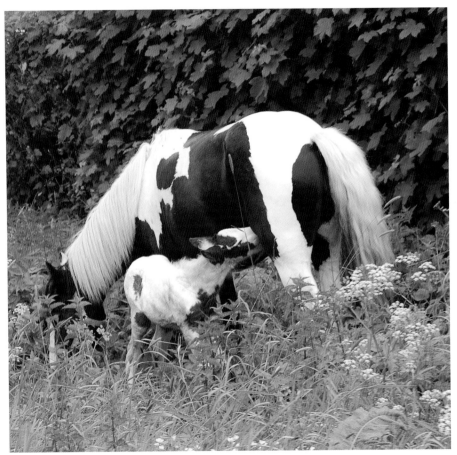

A tiny foal less than 10 days old feeds from its mother while traffic passes close by.

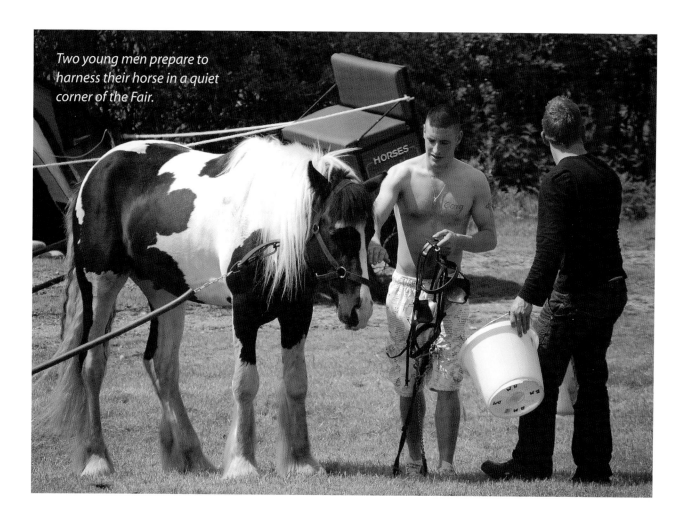

Two young men prepare to harness their horse in a quiet corner of the Fair.

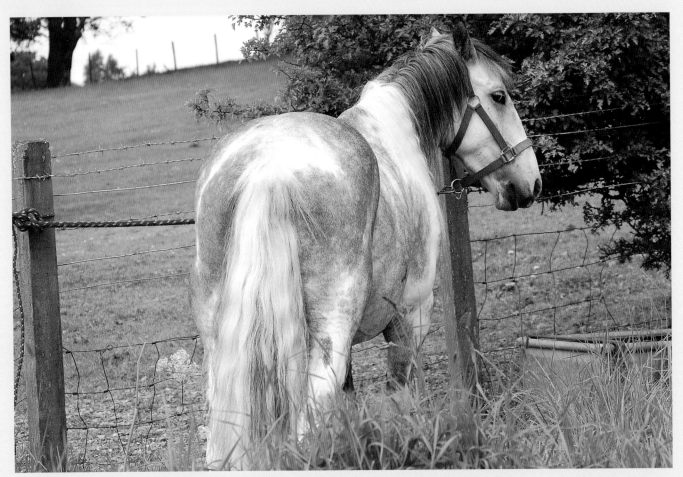

Tethered to a convenient fence post with plenty of grass to graze.

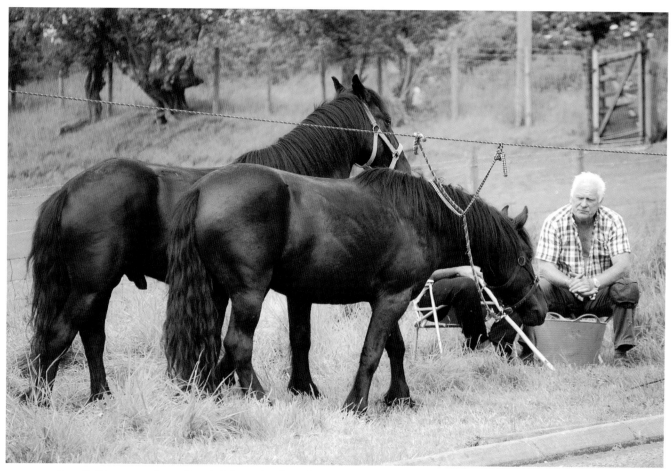

Two Fell type ponies – Cumbria's native breed – under a watchful eye and tethered to a running line.

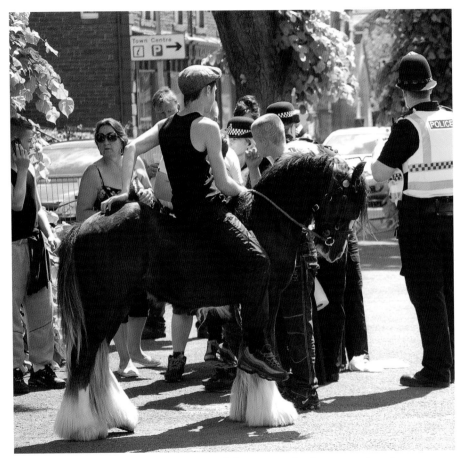

The police maintain a peaceful presence in the town chatting to fairgoers and offering advice when needed.

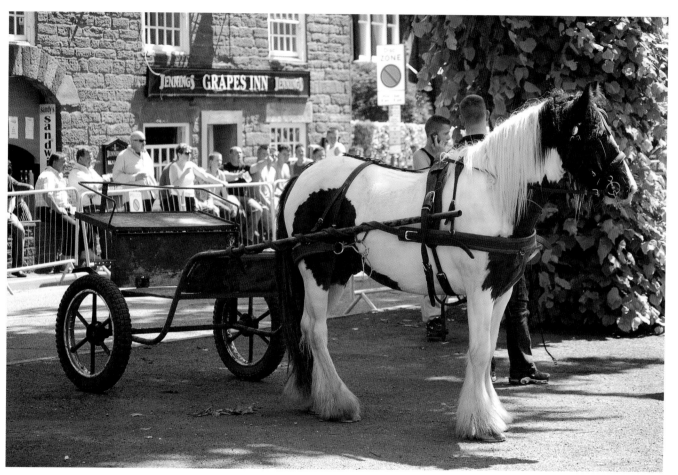

Harnessed and ready to go.

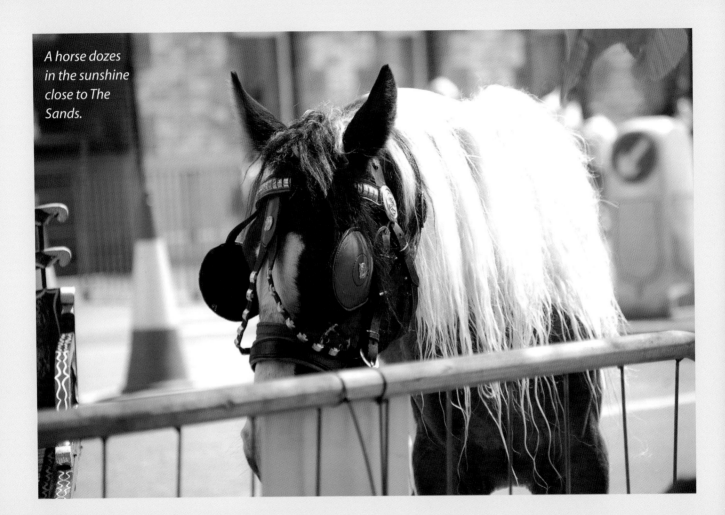

A horse dozes in the sunshine close to The Sands.

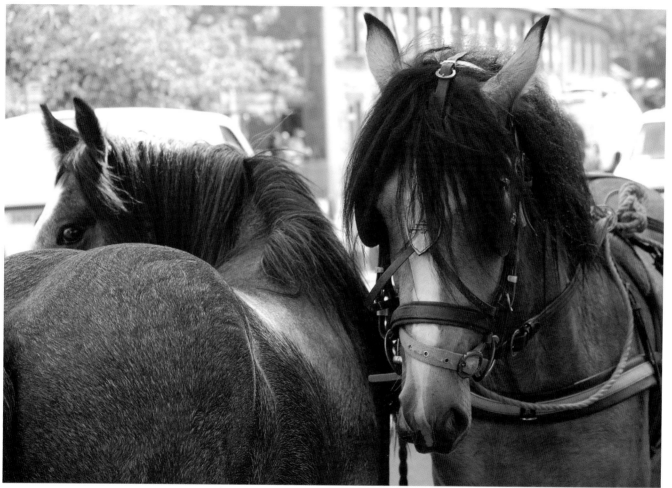

Two horses wait side by side in the shade.

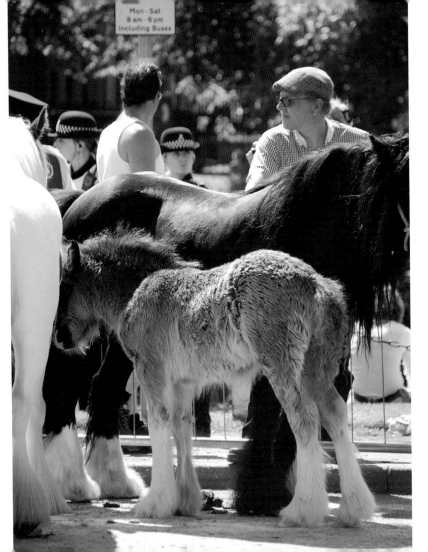

Foals are hardly ever haltered at Appleby and stay close to Mum.

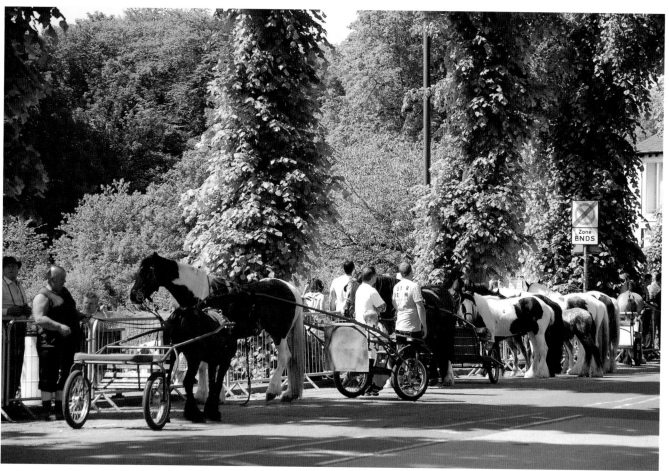

A scene as old as the Fair itself.

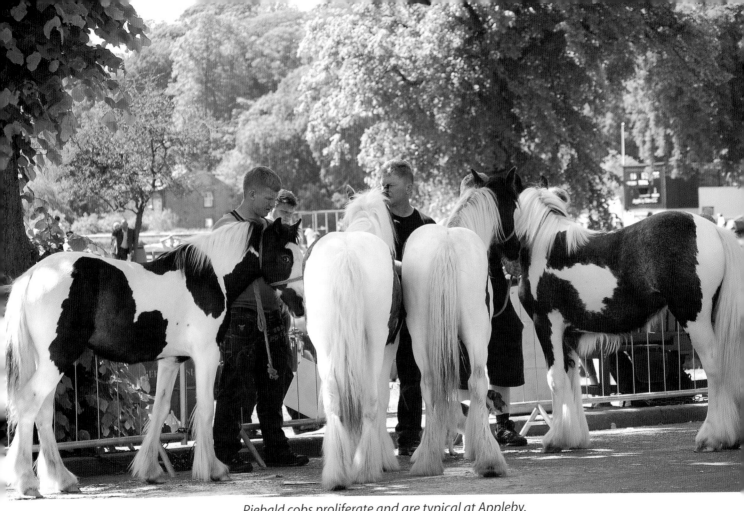

Piebald cobs proliferate and are typical at Appleby.

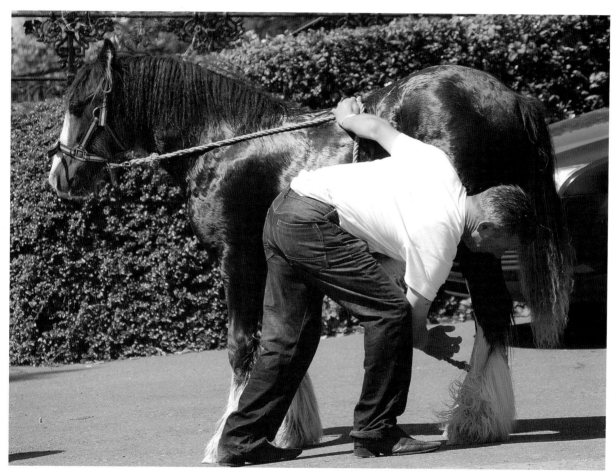

Taking time to check that all is as it should be.

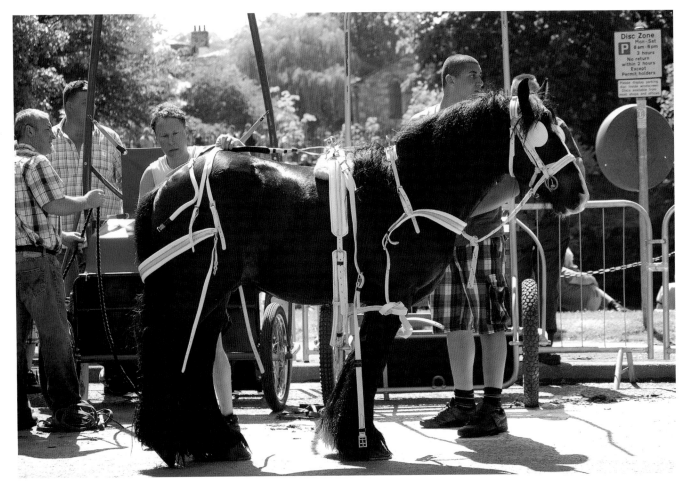

Fully harnessed.

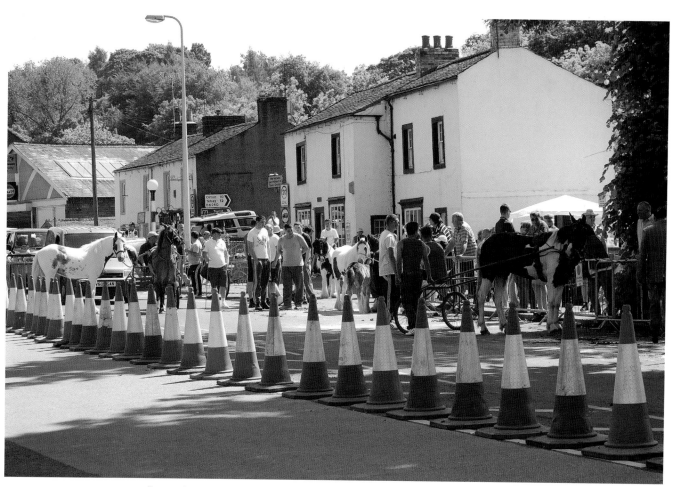

From time to time the road goes quiet and the horses cease to pass.

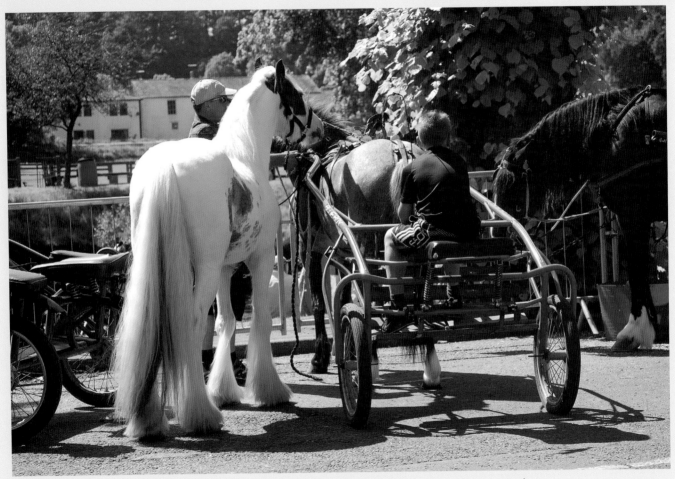

Alongside the river is a favourite place to rest and soak up the atmosphere.

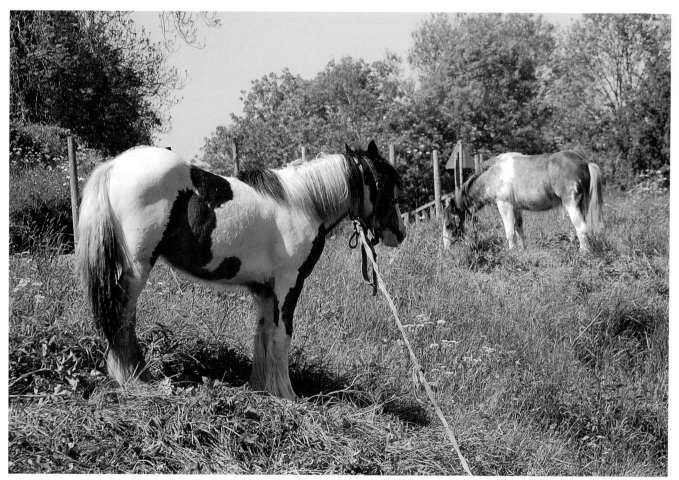

There are plenty of places to graze horses at Appleby.

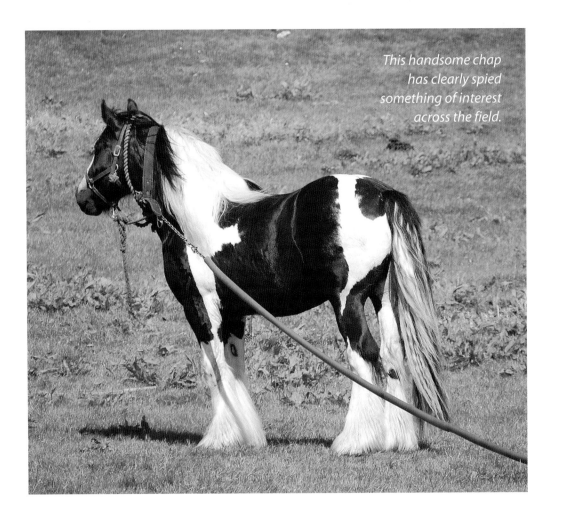

This handsome chap has clearly spied something of interest across the field.

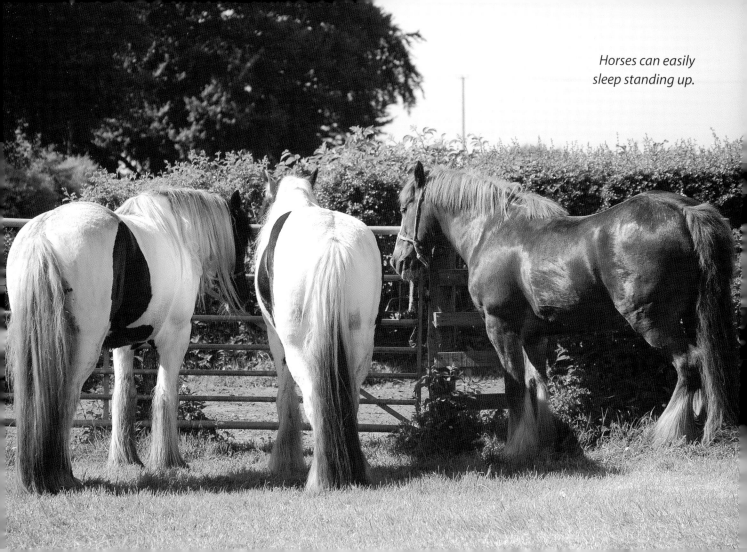

Horses can easily sleep standing up.

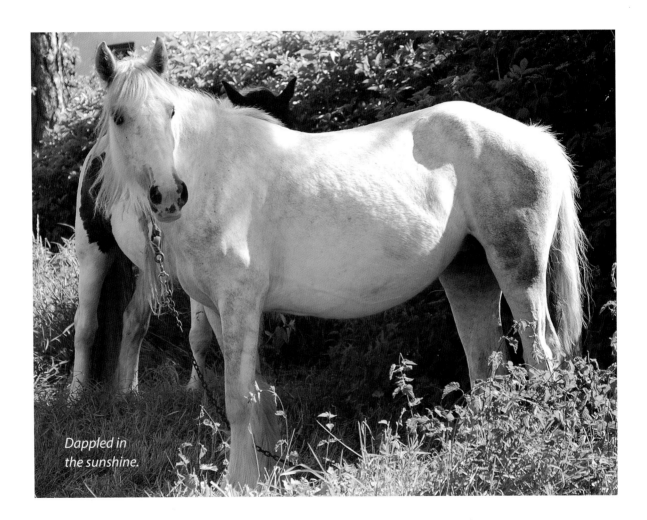

Dappled in
the sunshine.

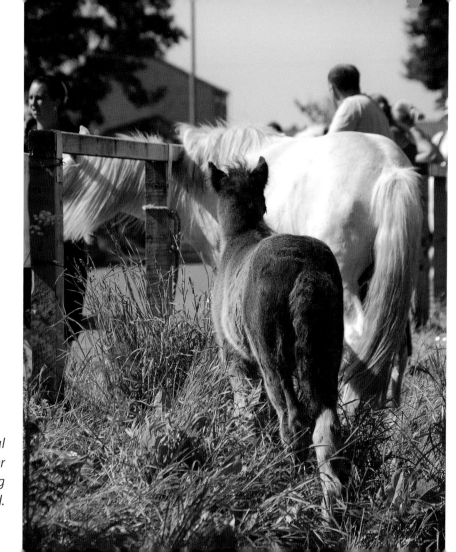

A young foal with its mother on the Long Marton road.

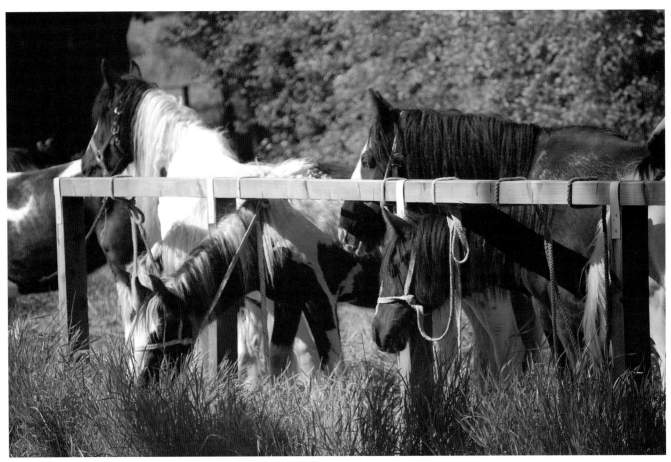

Rails are used for tethering and keeping horses off the flashing lane.

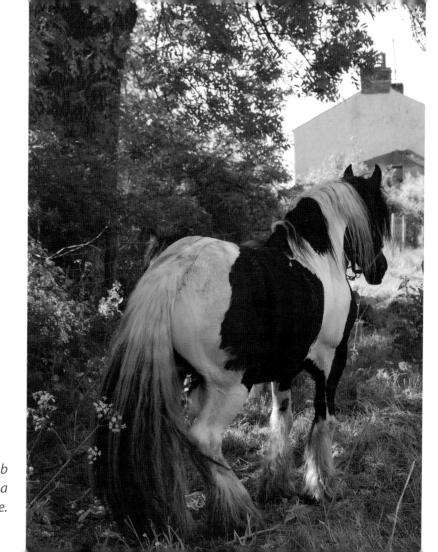

A cracking cob waiting for a sale.

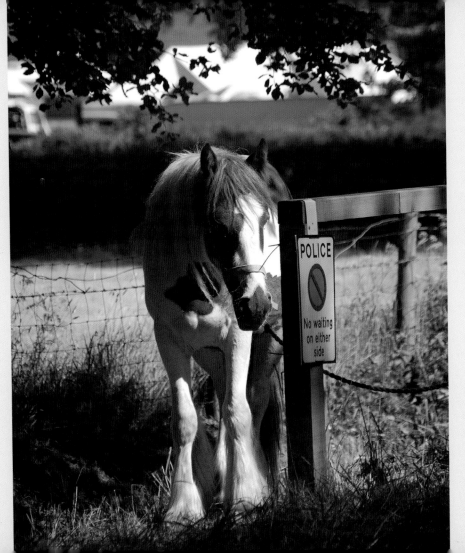

This spotted pony and his companions may well be sold as children's ponies.

Skewbalds are often outnumbered by their piebald counterparts but in days gone by numbers of coloured horses were more evenly split.

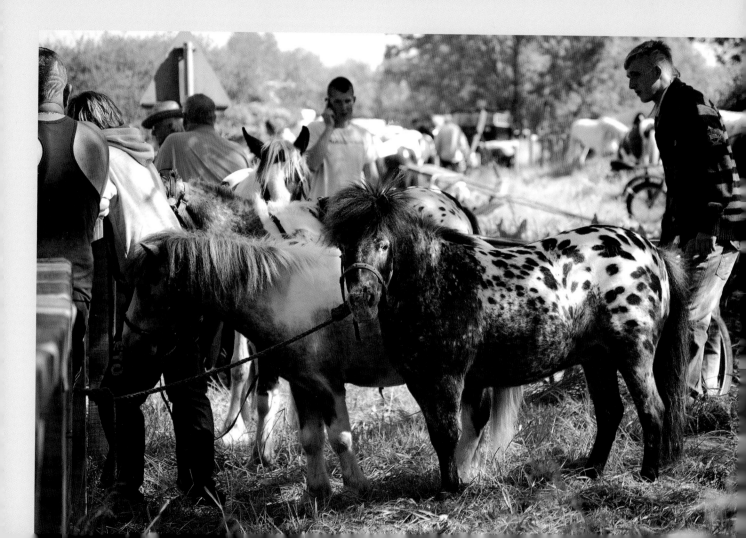

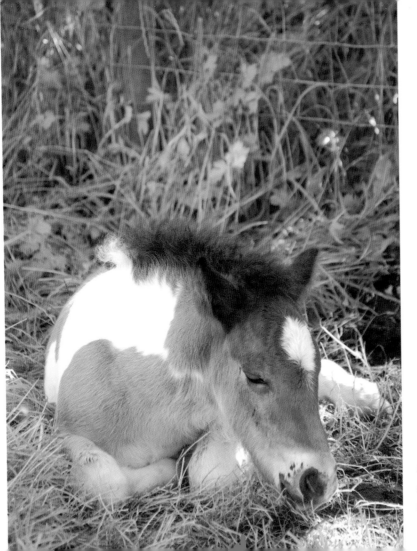

Cute and drawing admiring glances from passers by.

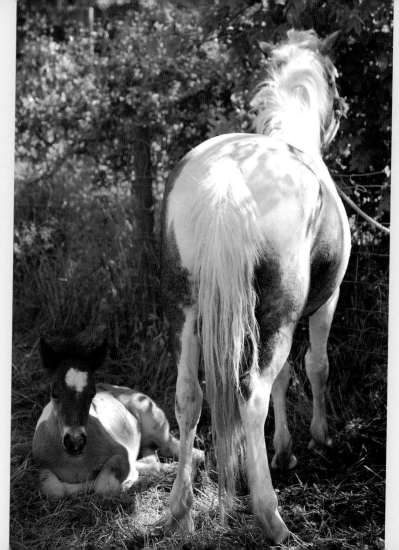

A mare rests with her foal at foot.

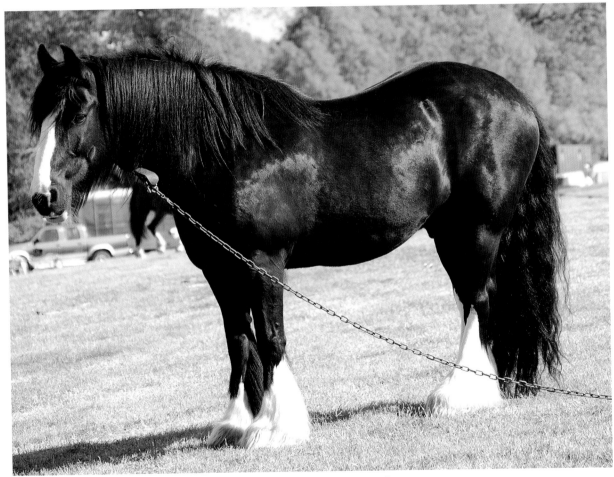

One of Appleby's fantastic cobs.

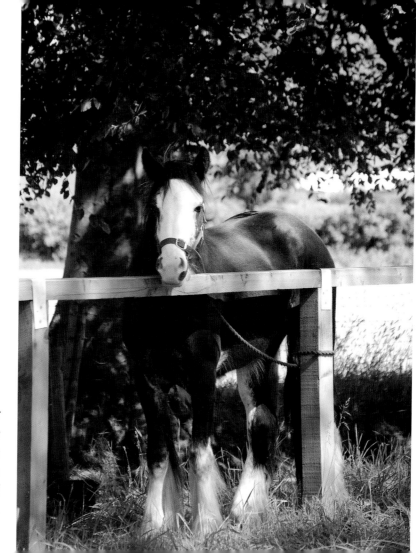

This youngster peeps over the rail while watching the comings and goings.

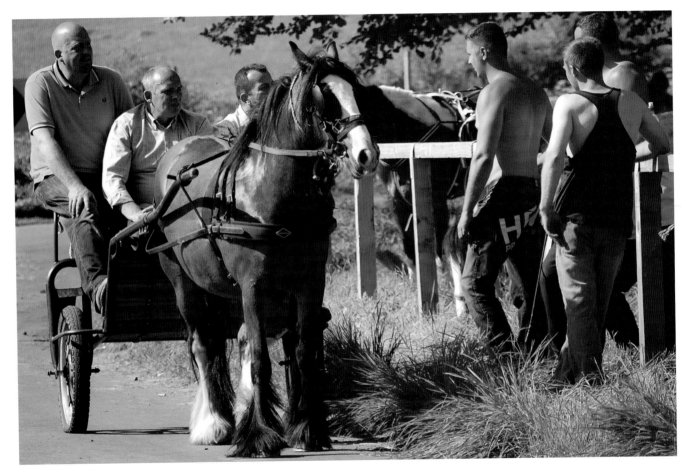

Stopping to chat.

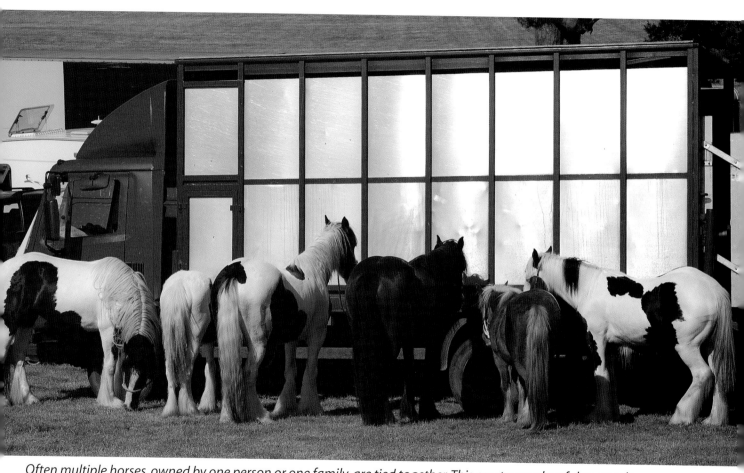

Often multiple horses, owned by one person or one family, are tied together. This creates a colourful spectacle.

Heidi M Sands

Born and brought up in the north-west of England, Heidi studied art and design at Preston Polytechnic and also at Blackpool and Fylde College. A life-long equestrian and award-winning writer, Heidi has a deep devotion to that part of Cumbria, once Westmorland, known as the Eden valley, from where generations of her own family originated.

www.heidimsands.ukwriters.net

Old Pond
PUBLISHING LTD

Founded in 1998, Suffolk-based Old Pond specialises in books and DVDs for the land-based industries from farm machinery and animal breeds to earthmoving, trucking and forestry.

Request a free catalogue:
Old Pond Publishing, Dencora Business Centre, 36 White House Road, Ipswich IP1 5LT, United Kingdom

www.oldpond.com